POSTCARD HISTORY SERIES

Sewickley

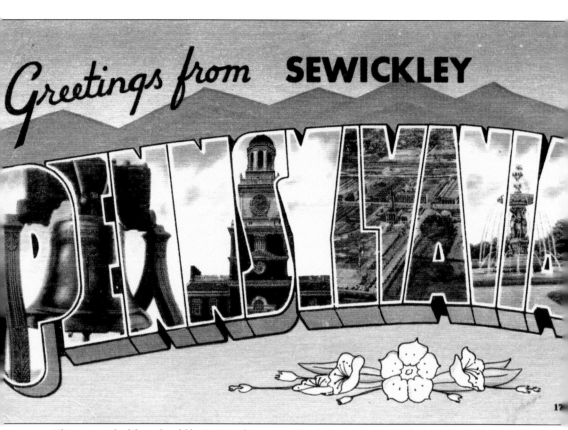

Greetings from **SEWICKLEY**

This postcard, although sold by Imperial Greeting Card Company in Pittsburgh and sending greetings from Sewickley, shows scenes from Philadelphia on the letters of the word "Pennsylvania."

On the front cover: This postcard shows the 1911 bridge over the Ohio River, looking from the Coraopolis shore toward the town of Sewickley. The handwritten message on the face of the card says, "Saw this but did not pass over it." (Courtesy of Dr. Leroy J. Egan.)

On the back cover: This postcard shows the Sewickley Station around 1920. The Pennsylvania and Ohio line first came through Sewickley in 1851, and in the heyday of passenger service around 1914, more than 80 trains stopped daily. Although there is still major movement of freight by rail, commuter service ceased in 1964. (Courtesy of Cynthia P. Giles.)

POSTCARD HISTORY SERIES

Sewickley

Sewickley Valley Historical Society

ARCADIA
PUBLISHING

Copyright © 2006 by Sewickley Valley Historical Society
ISBN 978-0-7385-4555-4

Published by Arcadia Publishing
Charleston, South Carolina

Printed in the United States of America

Library of Congress Catalog Card Number: 2006924303

For all general information contact Arcadia Publishing at:
Telephone 843-853-2070
Fax 843-853-0044
E-mail sales@arcadiapublishing.com
For customer service and orders:
Toll-Free 1-888-313-2665

Visit us on the Internet at www.arcadiapublishing.com

Dedicated to Mary Eleanor McPherson (1910–1985)
and Elizabeth Jane McPherson (1907–1996),
lifelong Sewickley residents, descendants of a pioneer family,
and donors to Sewickley Valley Historical Society.

CONTENTS

ACKNOWLEDGMENTS

The authors gratefully acknowledge the following individuals and institutions for sharing postcards to enhance the collection of the Sewickley Valley Historical Society: Allegheny City Society; Gloria G. Berry; Milana K. Bizic; Michael Westcott Brown; Dr. Leroy J. Egan; Cynthia P. Giles; Lake County Discovery Museum, Wauconda, Illinois; Margaret Mather Marshall; Betty G. Y. Shields; Marjorie R. Williams-Super; Frank Sr. and Melissa Wisen; Frank Wisen Jr.

INTRODUCTION

The Sewickley Valley, beautiful in situation and rich in history, is today a collection of municipalities comprising the Quaker Valley School District, occupying six miles of broad bottomland, elevated terraces and heights above, 12 miles downriver from Pittsburgh on the north bank of the Ohio River.

In Native American times, the river teemed with fish and birds, and forests were filled with game. The fertile floodplain was perfect for growing corn. In early spring, the American Indians tapped the area's abundant sugar maples, which they called "Seweekley" trees, for their sweet water. This is the traditional origin of the name Sewickley.

Because what would become Sewickley lay in a major corridor that led westward, the area was witness to momentous events in the last half of the 18th century: the French and Indian War, Pontiac's Rebellion, and the American Revolution. In November 1753, George Washington traveled along the Beaver trail to Logstown below present-day Ambridge, and, ultimately, to Fort LeBoeuf, to serve notice on the French trespassers competing with the English for the American Indian trade.

In 1764, Col. Henry Bouquet, following his victory at Bushy Run, traveled along the same Beaver trail with 1,500 men to treat with the American Indians of the Ohio region. He returned triumphantly, bringing back scores of white captives.

The first mention of the area in print comes in a letter dated December 31, 1767, from a trader named John Campbell, in which he laments the loss of a canoe. "She was seen passing the Sewicly [sic] Bottom . . . that night and was sound," he wrote.

In 1779, the Delaware Indians offered Col. George Morgan, the first American Indian agent at Fort Pitt, a strip of land including Sewickley Bottom as a personal gift. He declined the honor.

After the Revolution, the American Indians' title to the land north of the river was extinguished by treaties signed at Fort Stanwix in New York and at Fort McIntosh, a 1778 fortification located in present-day Beaver, Pennsylvania. This land was appropriated for redemption of depreciation certificates given to Pennsylvania veterans in lieu of money for services in the war. Daniel Leet and Nathaniel Breading (or Braden) had surveyed two sections of the Depreciation Lands within the Sewickley area in the summer of 1785. The lots were sold in Philadelphia, yielding about $2 an acre. As the American Indians were not yet pacified, little of the land was purchased by veterans; most of it was scooped up by speculators.

In 1792, Gen. Anthony Wayne was charged with finally subduing the American Indians. He raised a 2,500-man force, which trained about eight miles downriver from Sewickley at an encampment known as Legionville (present-day Baden). Wayne's Legion widened and

improved the Beaver trail running through Sewickley into a military road connecting Forts Pitt and McIntosh. The American Indians were crushed at the 1794 Battle of Fallen Timbers in Ohio, ending all resistance against future American settlement of the Northwest Territory. An immense tide of immigration followed, and the Ohio Valley funneled these pioneers into the continent's heartland.

The first permanent settlers in the Sewickley Valley had arrived by the end of the 18th century. A retired sea captain, Henry Ulery, bought Lot 1 of Leet's Depreciation Land District, named Loretto, in 1798 and built a log house overlooking the Ohio, near where the Sewickley Bridge is today. Ulery used a team of oxen to pull boats through the shallows there, including, in 1803, Meriwether Lewis's keelboat, heading west on the epic journey of discovery. A lot upstream from Ulery's called Aleppo was purchased in 1802 by Thomas Beer, who kept a tavern close to the river.

In 1785, Caleb Way bought Lot 2 of Leet's survey, named Way's Desire, which today comprises the eastern portion of Edgeworth Borough and, in 1797, his son John Way occupied it. John's house, completed in 1810, was the first brick structure between Pittsburgh and Beaver. Maj. Daniel Leet, who had surveyed the area, acquired seven choice lots, giving his heirs in the Shields and Wilson families control of what is today the western portion of Edgeworth.

These early residents were farmers, but inns and taverns soon sprang up to accommodate the increasing traffic. Flatboats and keelboats crowded the river. These were the days of the legendary keelboat man Mike Fink, born in Fort Pitt around 1780. Conestoga wagons lumbered by on the Beaver Road, along with droves of cattle, pigs, and turkeys. In time, there was daily stagecoach service from Pittsburgh to Beaver. A post office named Sewickley Bottom was established in Newington, the home of David Shields, who became the postmaster. Early names for the area testify to the wildness of the times: Devil's Race Track, Contention, and Dogtown.

Two noteworthy developments brought respectability and permanence to the community. In 1837, James and Mary Olver moved their school for young ladies from Pittsburgh to Sewickley Bottom. The Edgeworth Female Seminary was named to honor novelist Maria Edgeworth. In the next century, the borough of Edgeworth adopted its name from this association, although the school closed in 1865. In 1838, an academy for boys was founded by John B. Champ and William M. Nevin. It exists today as the coeducational Sewickley Academy. Students from up and down the river were soon seeking a genteel education in Sewickleyville, as the residents decided to call their town in 1840.

The pace quickened with the arrival of the Ohio and Pennsylvania Railroad in 1851, transforming what was a sparsely settled rural community into a highly desirable suburban area. Eventually there were stations at Haysville, Glen Osborne, Sewickley, Quaker Valley, Edgeworth, Shields, and Leetsdale. It now became convenient to commute to Pittsburgh; a journey that took about four hours by road and two hours by steamboat was now reduced to a mere half hour. The population doubled in the next decade, now that businessmen could escape the dirt and congestion of the city for a quiet home on a large lot in the Sewickley Valley. In addition, railroad men took up residence here, joining the steamboat captains who had already found life in the valley congenial.

On July 6, 1853, the borough of Sewickley was incorporated, with separate election and school districts, and in 1856, Alexander Hays, who later distinguished himself in the Civil War, made the first official survey and map of the borough. In the period that followed, the town quickly developed the foundations of the modern community.

In 1859, land was purchased above the town for Sewickley Cemetery. The many religious denominations that had been present in the area since its first settlement constructed impressive sanctuaries. A library association was formed in 1873; a waterworks was completed in 1874. In 1876, Cochran Hose Company, Sewickley's volunteer fire department, was organized. The Sewickley YMCA was founded in 1894, and the Sewickley Valley Hospital opened its doors in 1907.

Plots were subdivided into residential neighborhoods with wide, tree-lined streets and large homes. The high quality of housing was no accident, as a large number of nationally known

architects lived and worked in the area. Most of the shops and services were along Beaver Street, although some light industry existed along the river. Heavy industry was confined to the western portion of the valley in Leetsdale, and even the oil derricks that were sprouting up in the area never marred the appearance of the Sewickley Valley proper. Osborne Borough was incorporated in 1883; Edgeworth Borough was incorporated in 1904.

The heights above Sewickley remained underdeveloped, even wild in some places, because the land was far from the river and therefore not readily accessible, and because the absentee owners did not exploit their holdings, leaving them to squatters and wildlife.

More than 1,600 acres in Breading's Depreciation District had been purchased by Thomas McKean, a signer of the Declaration of Independence and Pennsylvania's first governor, and his partner, Francis Johnson. McKean bought Johnson's interest in 1803 and presented the whole to his daughter, who had married the Spanish ambassador to the United States. She left the property to her daughter, but both women remained in Spain. This is the origin of the name of Spanish Tract Road in Sewickley Heights.

The Spanish Tract and adjoining land were purchased in the 1890s by Cochran Fleming, who intended to develop a dairy farm. Hilltop sites were cleared, fences and barns were built, but the operation went bankrupt even before livestock was purchased. At the foreclosure that followed, four Pittsburgh businessmen who had organized the Tuxedo Land Company purchased Fleming's 2,200 acres for $38 an acre. The new owners retained acreage for themselves and sold some to carefully chosen men of wealth, who found the rolling hills and spectacular views perfectly suited for their summer estates.

This was the era when most of Pittsburgh's industrial elite lived in Pittsburgh's East End or on Ridge Avenue in Allegheny City, today's North Side. They spent their summers at Cresson Springs and Bedford Springs, and at South Fork Club near Johnstown, but they were looking for new diversions. Allegheny City was becoming crowded, and the annexation of their town by the city of Pittsburgh was impending; it was accomplished in 1906.

Henry W. Oliver, the steel pioneer who developed the great Mesabi Range, was one of the first to spend summers in Sewickley, and he soon recruited others. Actually, people had been spending summers in the Sewickley Valley ever since the arrival of the railroad in 1851, but now came high society.

In 1896, Oliver purchased 65 acres extending from where the YMCA is today to the crest of Blackburn Road. He remodeled a small farmhouse on the property and built a barn for his carriages and driving horses. Before long, his daughter and son-in-law, Edith and Henry Robinson Rea, erected a mansion nearby and named it Farmhill. Other magnificent estates soon covered the hilltops. These were the summer homes of some of America's wealthiest families, and they gave Sewickley a far grander image than it had enjoyed before 1900. Numerous people were employed on the estates, many of which were farming operations, and a service industry developed in the town, geared to supplying the new neighbors' needs.

The heights grew even more attractive when Allegheny Country Club moved from its original location in Allegheny City and opened its 18-hole golf course in 1902. As roads were improved and the automobile made access more convenient, some of the great houses were converted to year-round use, and a permanent community grew with the country club as its focus. In 1935, Sewickley Heights Borough was formed to organize the community and preserve its unique character. Most of the estates have now disappeared, but the Allegheny Country Club remains.

The acreage of the Tuxedo Land Company that was not developed became the Sewickley Heights Trust. In 1995, hundreds of acres, comprising the pristine watershed of Little Sewickley Creek, were presented to the public as Sewickley Heights Park, to preserve the sylvan character of the area.

In 1911, the Sewickley-Coraopolis Bridge was completed, uniting the north and south banks of the Ohio River and rendering the three local ferries obsolete. In 1929, the tracks of the Pennsylvania Railroad were moved closer to the river, making way for the construction of Ohio River Boulevard, completed as far as Sewickley in 1934. Increased reliance on the automobile

eventually spelled the end for passenger rail service.

Sewickley was conveniently proximate to the Pittsburgh airport when it was constructed after World War II. In 1981, after fierce lobbying by local residents, a new Sewickley Bridge was built to replace the aging 1911 span.

And so the town proceeds, a living museum, endeavoring to preserve its past while embracing the future, blessed by luck, geography, and careful planning by its residents.

One

THE RIVER, THE ROAD, AND THE RAILROAD

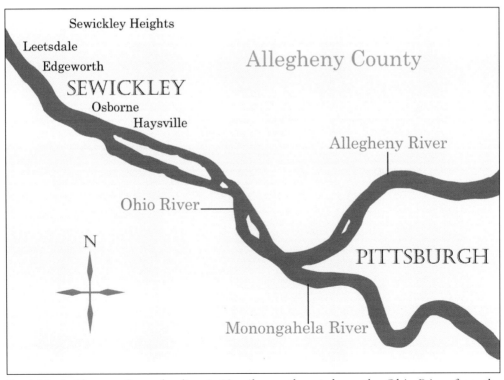

Sewickley's Chestnut Street landing is 12 miles northwest down the Ohio River from the confluence of the Allegheny and Monongahela Rivers at Pittsburgh.

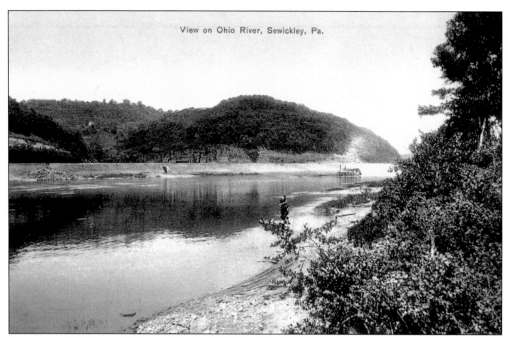

View on Ohio River, Sewickley, Pa.

The Ohio River valley has always been a major thoroughfare affording access to the West. Travelers and freight move on the river, via Beaver Road and the later Ohio River Boulevard, and since 1851, by railroad. This view from the Sewickley shore shows a steamboat coming up the narrows by Deadman's Island. Notice the high gravel banks and relative shallowness of the river before dams were built.

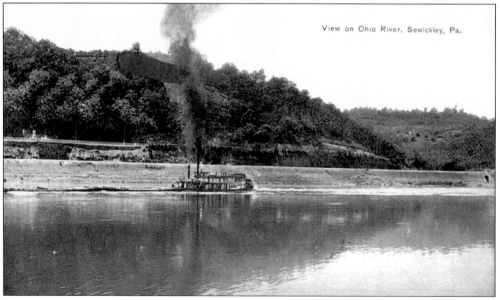

View on Ohio River, Sewickley, Pa.

Canoes, flatboats, and keelboats were the craft of choice until the steamboat *New Orleans* was built in Pittsburgh. It successfully navigated downriver under its own power in 1811, inaugurating an age of steam, which saw boats penetrating to the headwaters of most tributary streams and becoming the best way to move passengers and freight. Here is the steamer *Darling*, built in Parkersburg, West Virginia, in 1871, traveling upstream by Sewickley.

12

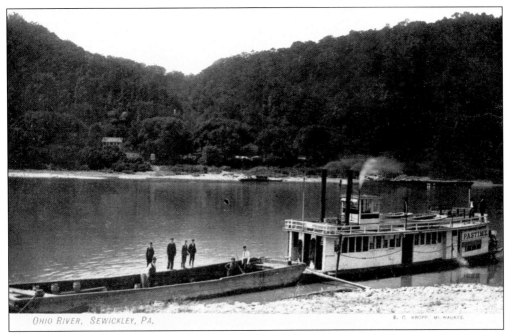

Pastime was a single-deck steamer built in 1900 in Pittsburgh. It traveled between Shousetown and Aliquippa, with stops at Old Economy, Leetsdale, and Sewickley. It sank in 1910. Note Stoops' Ferry lying offshore in the background.

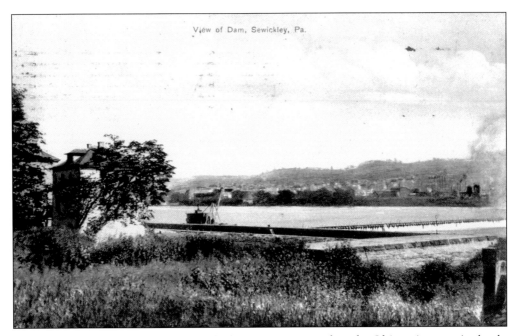

Beginning in the late 1800s, dams and locks were constructed on the Ohio to increase its depth. Three were built, at Davis Island, Neville Island, and Glen Osborne, thereby maintaining a nine-foot pool of water. These were dams with movable wicket gates.

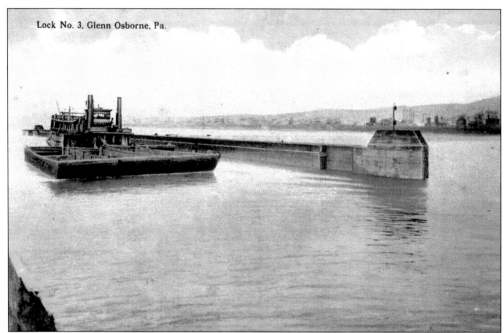

Lock No. 3, Glenn Osborne, Pa.

Dam and Lock No. 3 at Glen Osborne were completed in June 1908. The lock was 600 feet long and 110 feet wide. In the 1920s, the first three dams on the Ohio River were replaced by the permanent concrete and steel structures seen today at Emsworth, opened in 1921, and Dashields, opened in 1929.

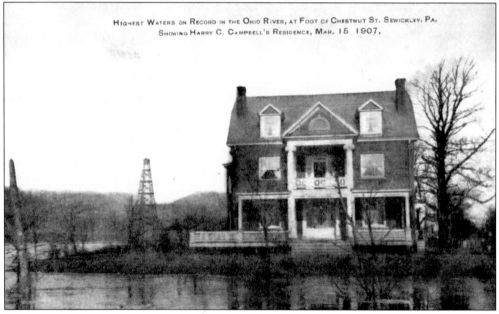

HIGHEST WATERS ON RECORD IN THE OHIO RIVER, AT FOOT OF CHESTNUT ST. SEWICKLEY, PA.
SHOWING HARRY C. CAMPBELL'S RESIDENCE, MAR. 15 1907,

The Ohio River watershed is prone to flooding. Flood stage at Pittsburgh is 25 feet, and that is often exceeded. The 1900 Campbell house, shown here in the 1907 flood, was moved from the local steamboat landing at the foot of Chestnut Street to Maple Lane, Sewickley, in 1928, when the railroad was being constructed closer to the river. The derrick in the background, owned by the Park Place Hotel, supplied it with natural gas to run a generator for electricity.

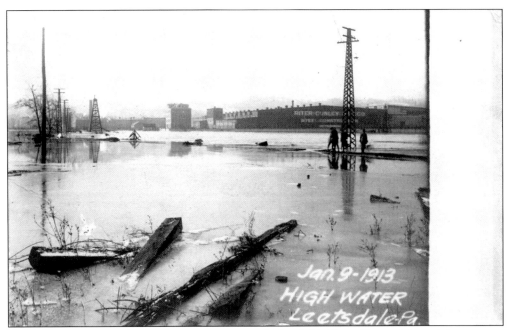

The low-lying Sewickley Valley communities of Glenfield, Haysville, and Leetsdale are most prone to flooding. This scene shows the Riter–Conley Manufacturing Company, Leetsdale, in 1913, surrounded by floodwaters.

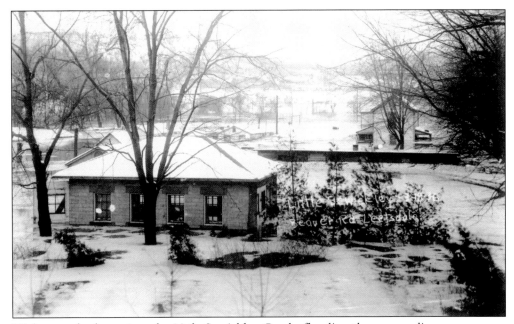

High water backs up into the Little Sewickley Creek, flooding the surrounding area, as seen in this 1936 postcard of Beaver Road, Leetsdale, during the St. Patrick's Day flood. Notice the river in the background.

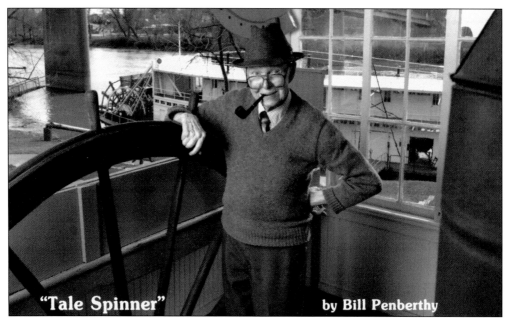

"Tale Spinner" **by Bill Penberthy**

Many river people, captains and crew, made Sewickley their home. This postcard depicting beloved Edgeworth native Capt. Frederick Way Jr. is a promotional piece from local photographer William J. Penberthy. Captain Way had a storied career on the rivers. He was founder and president for many years of the Sons and Daughters of Pioneer Rivermen and authored a number of books, becoming the foremost authority on America's inland waterways before his death in 1992.

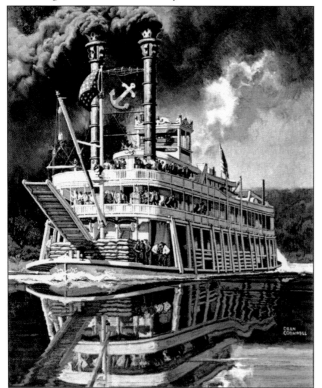

This Dean Cornwell painting shows the steamer *Betsy Ann*, captained beginning in 1925 by Frederick Way Jr. This image was used on a 34¢ U.S. postage stamp. The *Betsy Ann* was constructed in 1899 in Dubuque, Iowa, for R. F. Leonard of Natchez, Mississippi, and named for his wife, Elizabeth. It was dismantled at St. Louis in the fall of 1940.

16

Capt. Frederick Way Jr. used this Cy Hungerford cartoon to send Christmas greetings to his friends in 1983. It depicts the 1928 race between the *Chris Greene* and the *Betsy Ann*. Way revived steamboat races on the river that recalled the old days. These events were widely publicized.

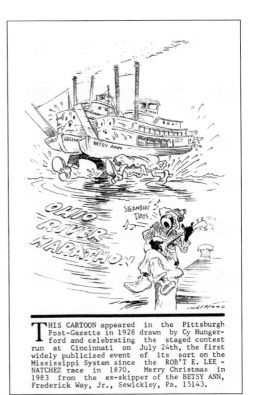

THIS CARTOON appeared in the Pittsburgh Post-Gazette in 1928 drawn by Cy Hungerford and celebrating the staged contest run at Cincinnati on July 24th, the first widely publicized event of its sort on the Mississippi System since the ROB'T E. LEE - NATCHEZ race in 1870. Merry Christmas in 1983 from the ex-skipper of the BETSY ANN, Frederick Way, Jr., Sewickley, Pa. 15143.

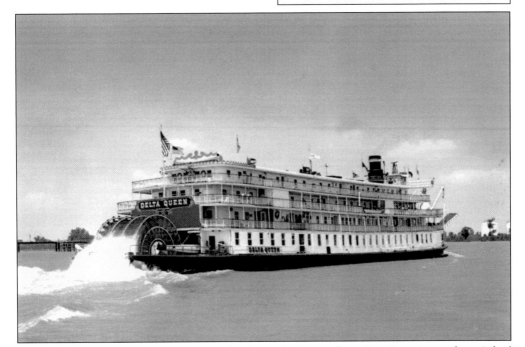

In 1947, Capt. Frederick Way Jr. brought the *Delta Queen* from San Francisco, where it had been performing wartime service, through the Panama Canal, and eventually to the Mississippi River system. In later years, when the vessel passed Sewickley, it often saluted Captain Way on its calliope with his favorite song, Stephen Foster's "Beautiful Dreamer."

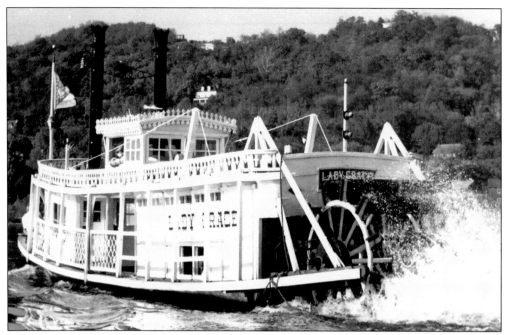

Lady Grace was the seventh of a number of pleasure craft, all named for his wife, and built by Capt. Frederick Way Jr. to entertain guests on the river. This one was launched in 1954. The captain at the helm in the wheelhouse gives some idea of the small scale of the vessel.

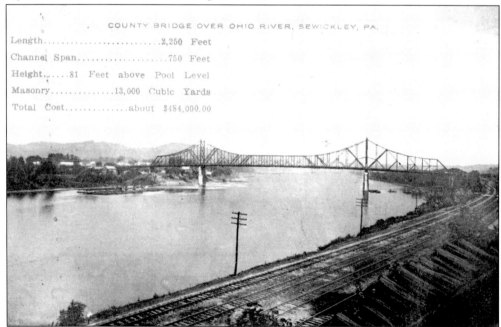

COUNTY BRIDGE OVER OHIO RIVER, SEWICKLEY, PA.

Length.....................2,250 Feet

Channel Span..................750 Feet

Height.......81 Feet above Pool Level

Masonry............13,000 Cubic Yards

Total Cost...........about $484,000.00

Before the Sewickley Bridge opened in 1911, the only way across the river was by ferry. High water, low water, and ice made crossing difficult. There was no bridge along the whole length of the Ohio River between Pittsburgh and Wheeling, and lobbying for one began in earnest in 1894. Construction finally began in 1909. This view is from the Stoops Ferry landing on the Coraopolis side of the river.

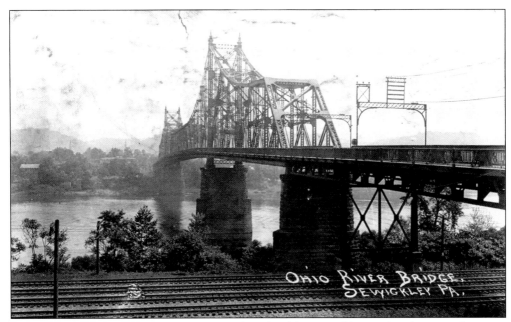

Note overhead electric lines on the Coraopolis side of the Sewickley Bridge. Streetcars began to cross the bridge from Coraopolis in 1913, but never were allowed in Sewickley proper. There was a turn-around and a little station where the Sewickley Car Store is located today. At the other end of the Sewickley Valley, the trolley came only as far as the Leetsdale-Edgeworth border on Beaver Road.

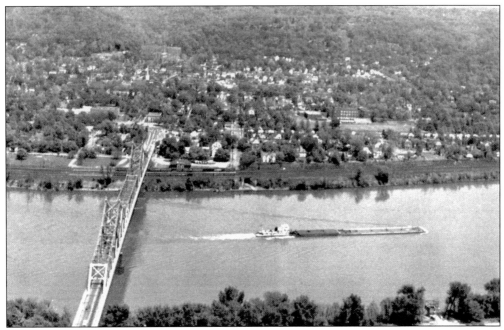

This card shows a diesel-powered towboat passing Sewickley and the bridge. The barges are actually pushed by the towboat. Large amounts of bulk cargo still pass by Sewickley on the river, despite railways on both banks. Pittsburgh is one of the largest inland ports in the United States.

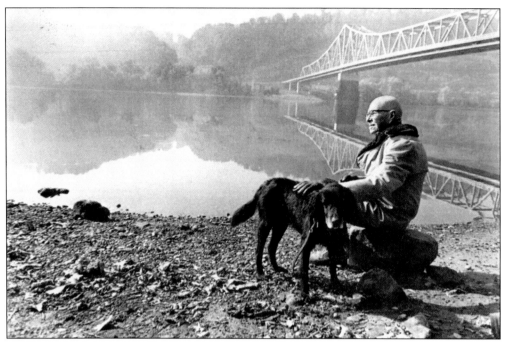

This postcard announcing an exhibition of photographs by Jane Freund shows Capt. Frederick Way Jr. and his dog Wrecks with the new Sewickley Bridge in the background. The 1911 Sewickley Bridge was closed to traffic in May 1980. A new bridge, costing 30 times more than the first, was dedicated in October 1981, only after impassioned efforts by a local Save the Bridge committee.

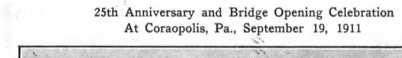

25th Anniversary and Bridge Opening Celebration
At Coraopolis, Pa., September 19, 1911

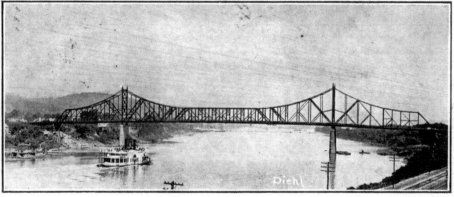

The New Allegheny County Bridge Connecting
Sewickley and Coraopolis

Sewickley and Coraopolis celebrated their first bridge with athletic competitions, fairs, concerts, pageantry, speech making, and a parade. The formal dedication came at 10:30 a.m. on September 19, 1911, as Burgess W. Kennedy Brown of Sewickley shook hands at mid-span with Burgess A. D. Guy of Coraopolis.

This painting by local artist Audley Dean Nicols graced the cover of the official program of the bridge celebration and was displayed as a poster in almost every shop. The image is still seen today, used as a logo by both Sewickley Borough and the Sewickley Valley Historical Society.

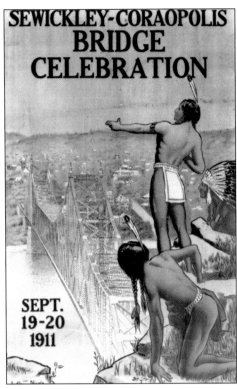

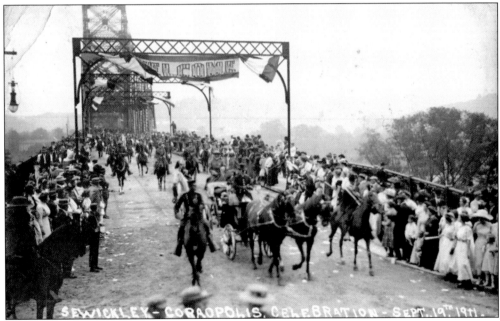

A parade was the highlight of the bridge-opening festivities. Here is the carriage of the grand marshal of the parade, Capt. John C. Anderson, followed by the mounted Spanish-American War veterans of Battery B. Captain Anderson was well known for his participation in the California gold rush of 1849, his adventures as a river boat captain, and his clear memory of Sewickley's early days. He died in 1928 at age 100.

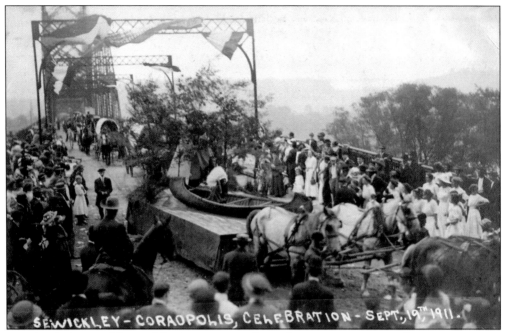

Here is a depiction of Queen Aliquippa sitting in front of a teepee, in a canoe. This Seneca woman, who was devoted to the English, was a prominent player in the events of the French and Indian War. All visitors to this region during that time paid court to her, including George Washington. Note the great crowd of spectators lining the bridge approach on the Sewickley side.

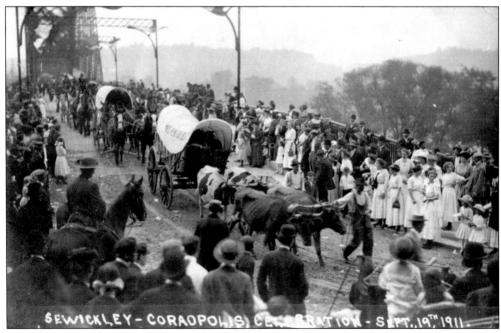

Following Queen Aliquippa's float were several Conestoga wagons that had been discovered in the cellar of an old barn in Coraopolis. One is drawn by two yoke of oxen, the other by teams of horses.

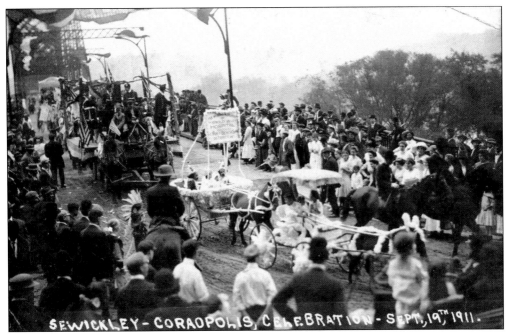

This is the Women's Auxiliary of the Sewickley Valley Hospital float. The auxiliary was organized in 1905, two years before the hospital opened. Since that time, it has provided millions of dollars and countless volunteer hours for the welfare of the hospital's patients and families.

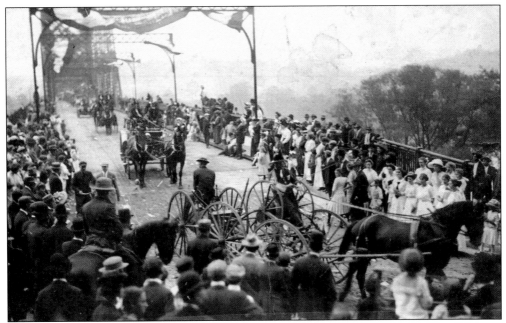

Sewickley's Cochran Hose Company was organized in 1876, largely through the efforts of Sewickley burgess George W. Cochran. The first wagon carries hoses; a fire engine follows.

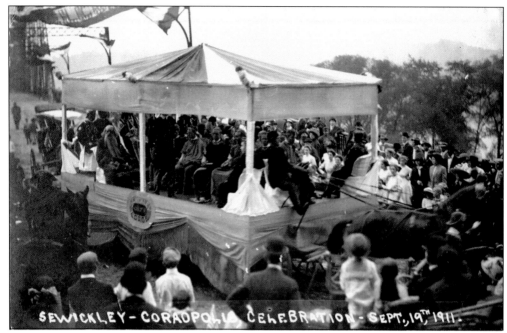

This float is from the Sewickley Lodge, but from which fraternal organization? There were lodges of Masons, Odd Fellows, and Knights of Pythias, to name a few. The gentleman with the long beard seated near the rear is believed to be Washington Gibb, one of Sewickley's older residents at the time. He would die in 1915 at age 85.

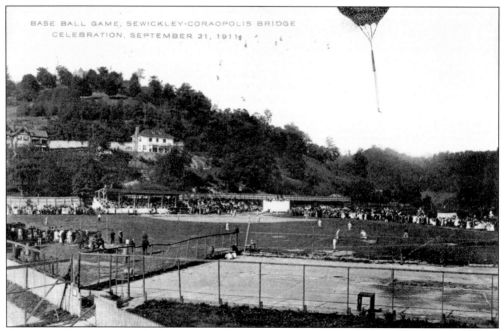

On September 21, 1911, the bridge-opening ceremonies culminated with a track-and-field meet and baseball game between Sewickley and Coraopolis at the Sewickley YMCA grounds, attended by 5,000 people. Sewickley won the game 7-5.

BEAVER ROAD, SEWICKLEY, PA.

Originally an American Indian trail, the road from Pittsburgh to Beaver was first widened and leveled for use as a military road in 1792 by Gen. Anthony Wayne. After his pacification of the American Indians in 1794, traffic on Beaver Road increased dramatically as thousands of Americans moved westward. This view is from the Little Sewickley Creek Bridge in Edgeworth, looking eastward.

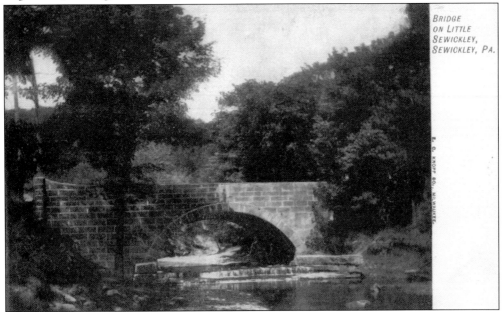

BRIDGE ON LITTLE SEWICKLEY, SEWICKLEY, PA.

This bridge over Little Sewickley Creek, built in 1841 and designated Allegheny County Bridge No. 1, was widened and relined in 1918. The view is looking upstream. This creek used to flow parallel to Beaver Road, starting at this point, meandering around through Edgeworth, until it was redirected about 1870 to flow straight into the river.

25

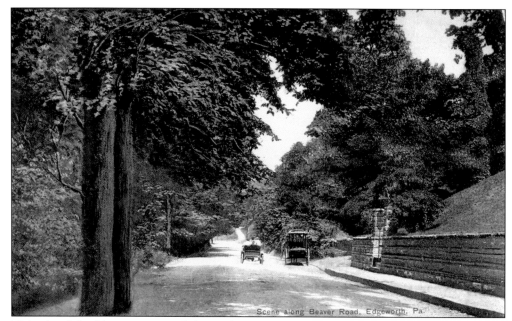

This view is looking west toward the Little Sewickley Creek Bridge and Leetsdale. There are fine homes on the high ground to the right, Shields Presbyterian Church and Newington to the left. Beaver Road was part of the Lincoln Highway, a transcontinental route designated in 1915 from New York to San Francisco in preparation for the Panama–Pacific Exposition, which promoted motor transport on highways. At this time, the road was first paved.

The sign at Meadow Lane points right to Beaver Road, Leetsdale Ferry, Economy, and Beaver. The Way Tavern and the Abishai Way house are to the right, just out of the picture. Mention of Economy is a reminder that the Harmony Society, a German Pietist sect, was Sewickley's nearest neighbor to the west. Until the demise of the Harmonists in the early 20th century, relations between the two communities were most cordial.

Beaver St. Looking East, Sewickley, Pa.

This view is from Academy Avenue looking east toward the village. A grand display of sycamore trees lined Beaver Street in the first decades of the 20th century. A few still survive. The thoroughfare is called Beaver Road in Edgeworth and Osborne. It is called Beaver Street in Sewickley and Leetsdale.

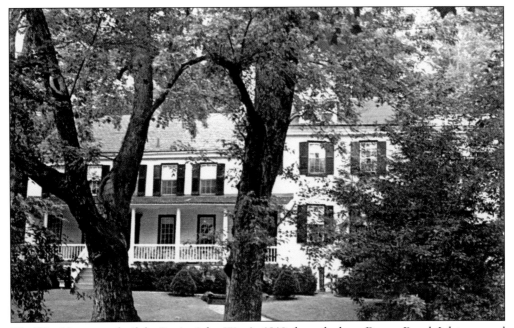

The Way House was built by Squire John Way in 1810 along the busy Beaver Road. It later served as a tavern and inn. It is a private home today. Mrs. Way's Quaker faith would be remembered in the name of the Quaker Valley railroad station nearby, in Quaker and Quaker Hollow Roads, and in the Quaker Valley School District.

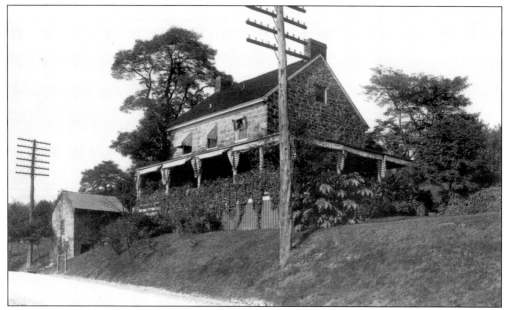

The Lark Inn was constructed around 1800 by Daniel Leet. Although the porch has been removed, it still stands near Little Sewickley Creek in Leetsdale and is a private residence. It was advertised as the "half-way house," because it was mid-way between Pittsburgh and Beaver. There were at least six such hostelries in the valley, testimony to the immense amount of traffic that came along the Beaver Road.

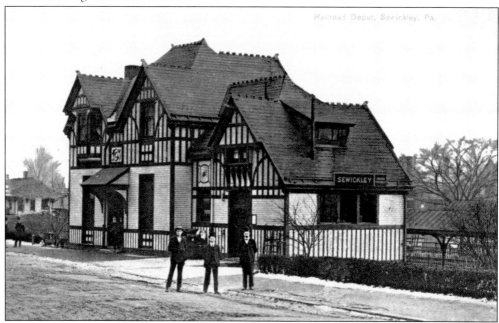

A single track of the Ohio and Pennsylvania Rail Road came through the valley in 1851. An inaugural passenger excursion from Allegheny City to Economy, where a celebration feast was served, was arranged for July 4. Soon regular service was established. It now took only 20 minutes to travel to Pittsburgh, and Sewickley changed from a village to a city suburb. Two rough board buildings preceded this elegant Tudor-style station constructed in 1887.

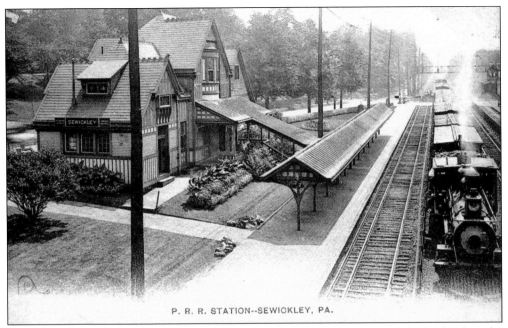

P. R. R. STATION--SEWICKLEY, PA.

In time there would be four tracks, two outside for passengers, and two inside for freight. The line was renamed the Pittsburgh, Fort Wayne and Chicago as it stretched westward, and in 1869, it became part of the Pennsylvania Railroad.

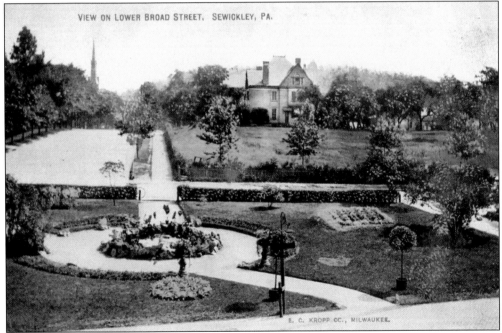

VIEW ON LOWER BROAD STREET, SEWICKLEY, PA.

E. C. KROPP CC., MILWAUKEE.

Sewickley's A. B. Starr, superintendent of freight transportation for the Pennsylvania Railroad, is credited with the railroad's plan to beautify stations. Gardener R. W. Hutchinson supervised the elaborate floral display at the foot of Broad Street. Plants and flowers used to beautify stations all along the line, as well as cut flowers and ferns for the café, dining, and sleeping cars, were grown in a conservatory west of the station.

29

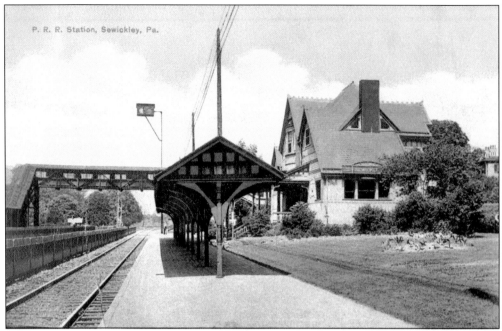

Heavy traffic necessitated a walkway for pedestrians over the tracks at Sewickley. There was a Union News stand at the foot of the stairs. After the building of the Sewickley Bridge, the crossing at Chestnut Street also became quite congested, and despite the presence of a guard to manage the gates, there were many accidents.

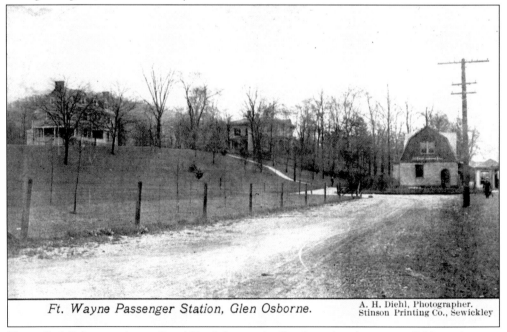

Ft. Wayne Passenger Station, Glen Osborne.

First called Osburn to honor Franklin Osburn who lived nearby, the name of this station was changed to Glen Osborne, because another station on the rail line bore the same name. The borough of Osborne was organized in 1883. This view looks east and shows the estates of James McKown and Charles Woods.

Many railroad executives called the Sewickley Valley home. In 1863, the president of the Pittsburgh, Fort Wayne and Chicago, "General" George Washington Cass, bought property just above this station and built a house called Cassella, considered one of the grandest in the valley. Cass moved from Sewickley in 1875. The house was later the home of novelist Mary Roberts Rinehart.

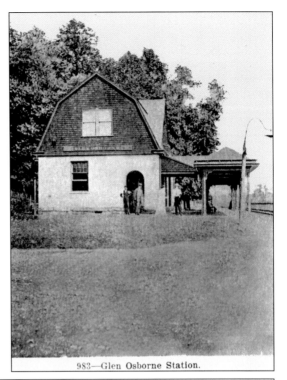

983—Glen Osborne Station.

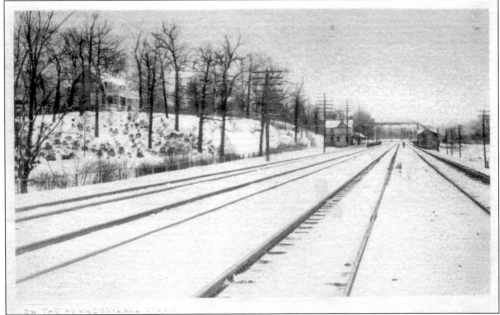

This is a view of Quaker Valley Station, at the foot of Academy Avenue in Edgeworth, looking east. Above is the home of W. C. Downing, superintendent of the Pennsylvania Railroad Lines West. The house still stands. This view shows the railroad right-of-way that became Ohio River Boulevard after the tracks were moved closer to the river. The boulevard was finished as far as the Sewickley Bridge by 1934 and extended west through Edgeworth in subsequent years. Increased use of the automobile killed passenger rail service.

31

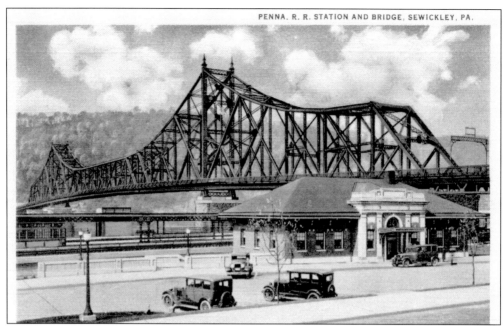

In 1929, the old Sewickley Station was moved intact on railroad flatcars to Chadwick Street, where it now serves as an American Legion post. The feat earned an entry in *Ripley's Believe It or Not*. This new station was constructed beside the 1911 Sewickley Bridge. Today trains no longer stop in Sewickley; the new station is a doctor's office.

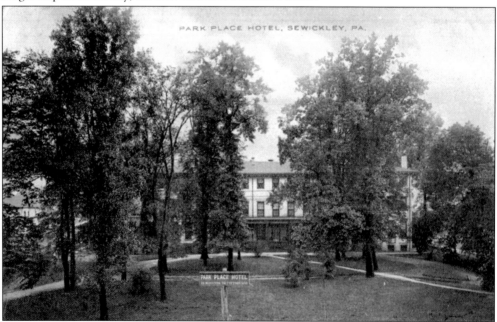

The railroad brought discerning travelers who sought luxurious accommodations, and the Sewickley Valley supplied them. There was an elaborate spa and hotel in Haysville called Ellanova Springs, which entertained excursionists until it burned in 1881, as well as the Park Place Hotel and Elmhurst Inn. This postcard shows the Park Place Hotel from the railroad, the sign in the yard announcing that it is only "13 minutes to Pittsburgh."

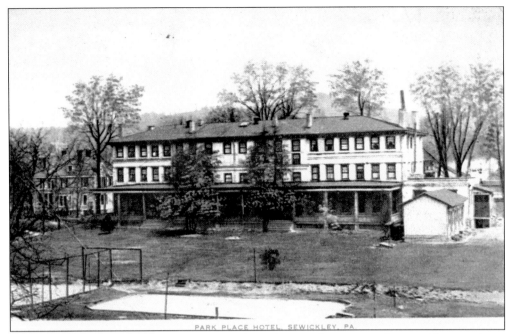

The Park Place Hotel, shown here in a view from the river, began as a private residence and was later acquired and enlarged for use as the Sewickley Academy. After 1863, it became a hotel. Broad Street did not line up with the Sewickley Bridge when it was constructed in 1911 because the hotel stood in the way. The Park Place Hotel was finally razed in 1938.

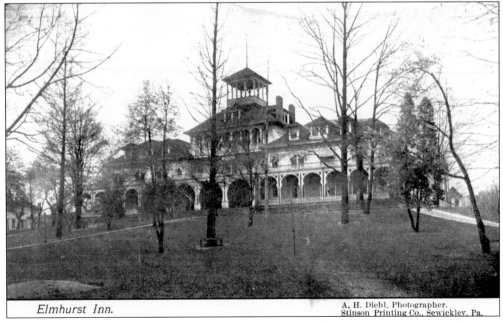

Elmhurst Inn.

Built as a private home named Elmwood around 1850, the Elmhurst Inn, expanded and topped with a cupola, served the railroad trade.

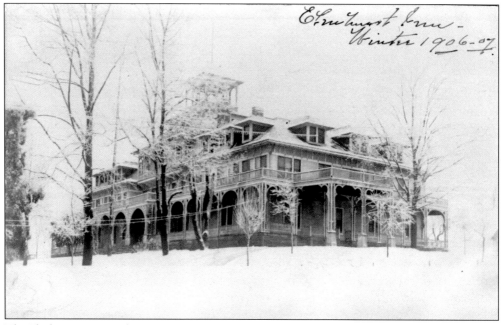

Elmhurst Inn —
Winter 1906-07.

The Elmhurst Inn, seen here in winter, was a sprawling edifice surrounded by fancifully decorated porches. After its glory days in the Gay Nineties, the hotel began a lengthy decline under at least six different owners.

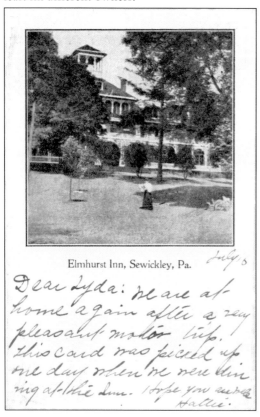

Elmhurst Inn, Sewickley, Pa. *July, 8*

Dear Lyda: We are at home again after a very pleasant motor trip. This card was picked up one day when we were dining at the Inn. I hope you are well. Hattie.

This card postmarked 1917 speaks of dining at the Elmhurst Inn while on a motor trip.

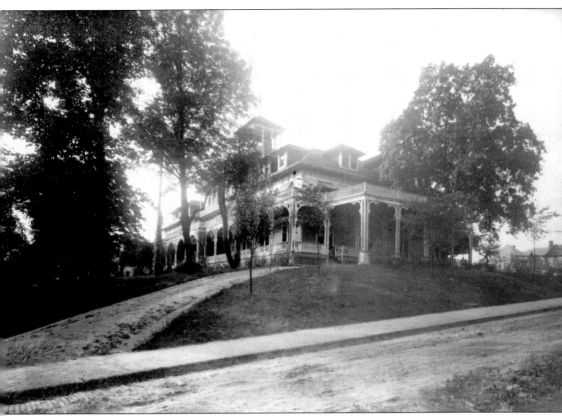

After World War I, the Elmhurst Inn assumed an air of shabby elegance. Its rooms were either too hot or too cold, the floors squeaked, and the cavernous dining room that doubled as a dance floor was not often filled, although it was still a venue for school dances and class reunions.

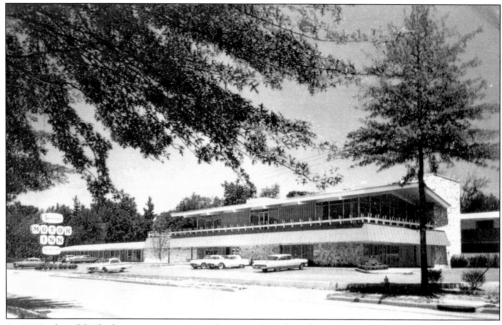

In 1959, the old Elmhurst Inn was torn down and replaced by the Sewickley Motor Inn, billed as a modern motor lodge constructed of stone, wood, aluminum, and glass, with a total of 100 rooms and a restaurant known as the River Room.

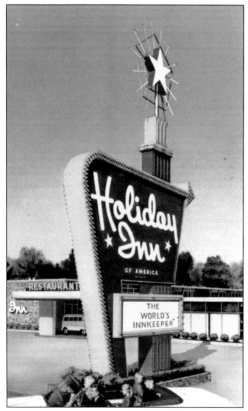

For a time beginning in the 1970s, the Sewickley Motor Inn became a Holiday Inn. In 1985, new owners remodeled and styled the place the Sewickley Country Inn. In that new guise, it served the community until it closed in 2009.

Two

THE VILLAGE
OF SEWICKLEY

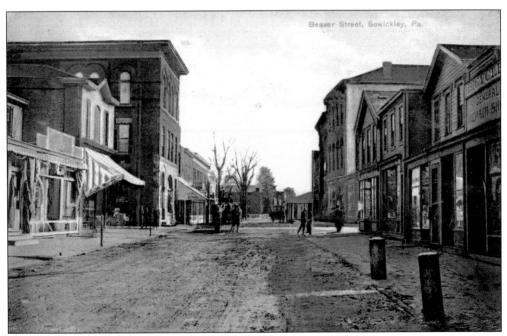

Beaver Street, Sewickley, Pa.

It is not hard to imagine the town sheriff walking down the main street at high noon, looking for a fight, in this early shot of Sewickley's Broad and Beaver Streets intersection looking east. Streets are unpaved, with no sidewalks. The three-story building on the left is the First National Bank, Sewickley's first bank, chartered 1890, which opened for business here in 1894.

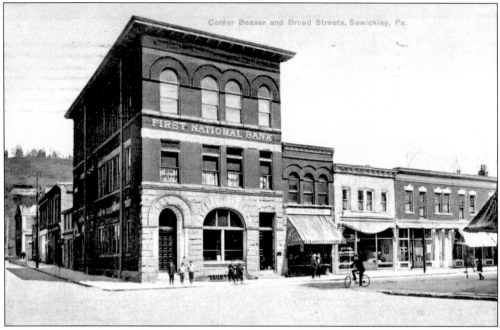

In this later view, Beaver Street has been graded and curbs added. The First National Bank was designed with two entrances, one into the bank lobby and another to the offices on the second and third floors. The Sewickley YMCA began meeting upstairs in this building in 1894. J. D. Miller sold shoes in the building next door. Cemetery Hill is in the background.

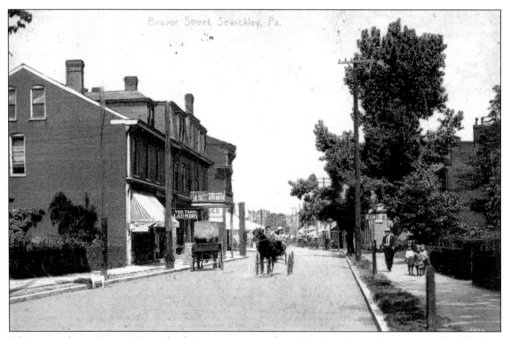

This scene shows Beaver Street looking west, near where Division Street intersects at the Flatiron Building. Notice the board sidewalk and the hitching posts on the right. The Yee Tang laundry is on the left. At one time, Sewickley had three Chinese laundries!

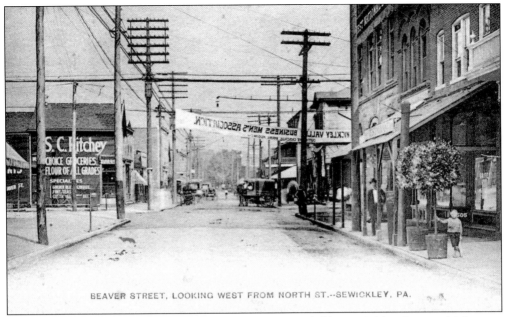

BEAVER STREET, LOOKING WEST FROM NORTH ST.--SEWICKLEY, PA.

There was no North Street. The reference in this card is probably to Division Street, which enters on the left and follows a north-south line from the 1785 survey. The busy juncture of Broad and Beaver Streets has always been Sewickley's Hollywood and Vine. S. C. Ritchey advertises boldly on a building that will be redesigned in 1916 with a facade inspired by a London street.

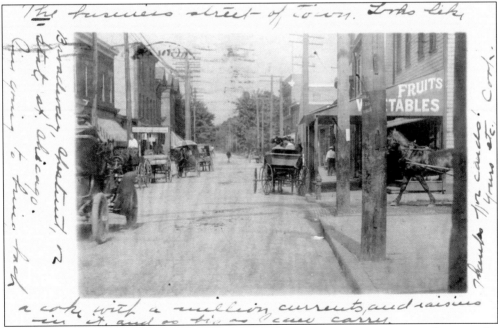

This card postmarked 1906, with a scene of Beaver Street looking west, Locust Street to the right, shows both automobiles and horse-drawn vehicles. It bears the humorous message, "THE business street of town. Looks like Broadway, Chestnut, or State St., Chicago. I'm going to bring back a cake with a million currants, and raisins in it, and as big as I can carry."

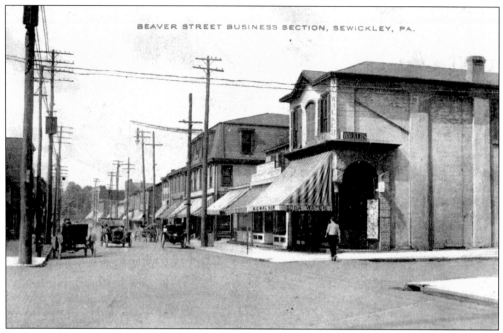

The sunny side of the main street was a boon to awning sales in the time before air-conditioning. This card shows the north side of Beaver Street at Broad Street, looking west. The Walker Drug Store building on the right corner has survived, as has the one next to it. The third story of the mansard-roofed Hegner Building was destroyed by fire in 1979.

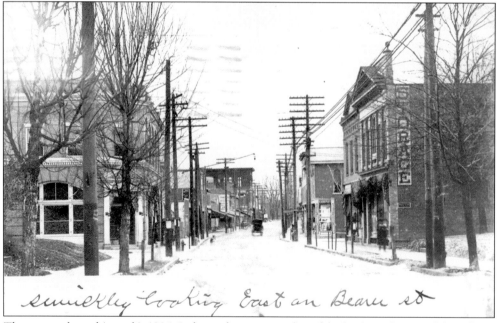

The postmark on this card is 1906. It shows the western edge of the business district of the village. To the left are Blackburn Avenue and the Sewickley Valley Trust Company.

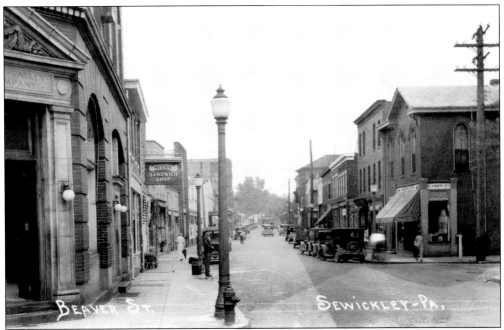

This card shows Sewickley Village in the 1920s. Notice that the utility poles have been removed. Old timers would remember the Myers Sandwich Shop, left, and S. Krepley's dry goods store on the right, on the corner of Beaver and Walnut Streets. The buildings have not changed much. Note the handsome lamp standards.

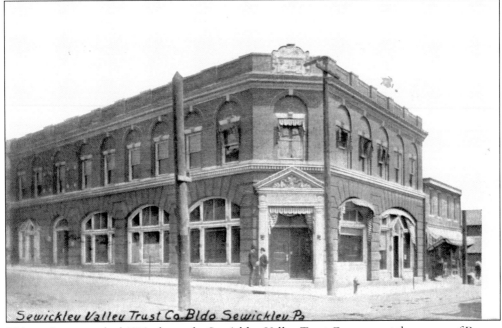

This card, postmarked 1913, shows the Sewickley Valley Trust Company at the corner of Beaver Street and Blackburn Avenue. This bank began doing business in this building in 1902. The extensive second floor was used for various purposes. The building was occupied in turn by Peoples Bank, Pittsburgh National Bank, and today by PNC Bank.

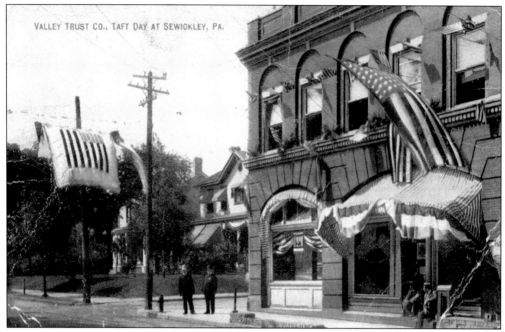

Flags were unfurled at the Valley Trust Company to welcome Pres. William Howard Taft on May 24, 1909. Taft came to Sewickley on the train from Pittsburgh and traveled to Sewickley Heights in a motorcade, turning at this corner, for a luncheon at the Rea's estate, Farmhill, followed by a reception at Allegheny Country Club.

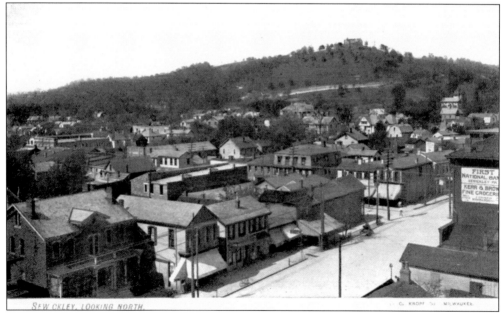

This view over the rooftops of Sewickley Village was taken from the tower of the Sewickley Public School on Broad Street. It shows Backbone Road in the background climbing up to the heights, the only access until Blackburn Road was constructed. The hilltop aerie is Hohenberg, designed by Alden and Harlow, the summer home of Allegheny City merchant Russell H. Boggs. The house no longer exists.

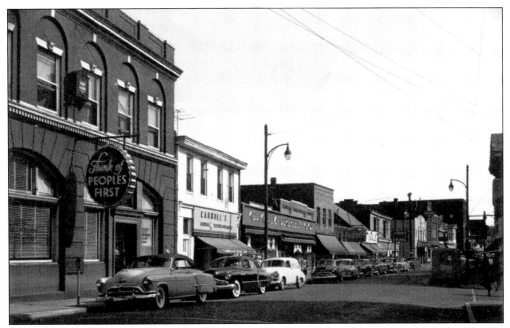

Parking on the north side of Beaver Street was not illegal when this card was published in the 1950s. Nor were signs like the one overhanging the sidewalk in front of what is now PNC Bank. Next door was Carroll's Music Store, the place to pick up records. The busiest place in the village, however, was the G. C. Murphy five-and-dime store.

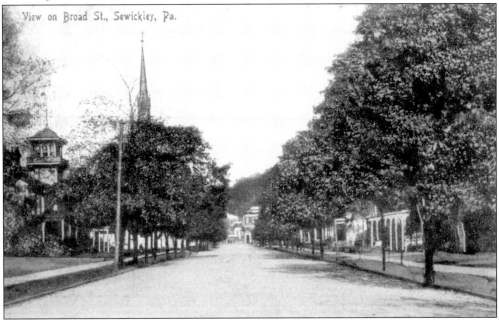

No traffic is stirring along tree-shaded Broad Street looking north in this card postmarked 1908. To the left of the Sewickley United Methodist Church steeple is the tower of the house of John Lent, who ran a landscaping business on the premises. Later acquired by the John Richardson family, during World War I, it became the headquarters of the Sewickley Red Cross. The property now belongs to St. Stephen's Episcopal Church.

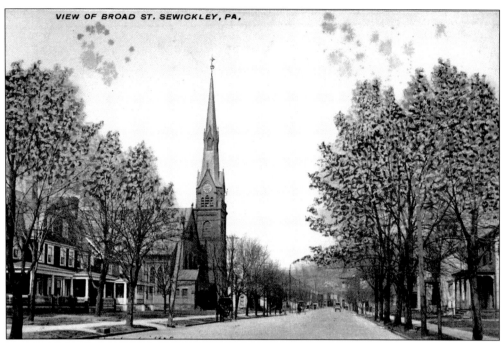

Again this is Broad Street looking north, in a view later than the previous one. The Methodist church was completed in 1884, with a spire rising 172 feet. In 1996, funds were raised by the community to restore the clock tower and sheath it in copper.

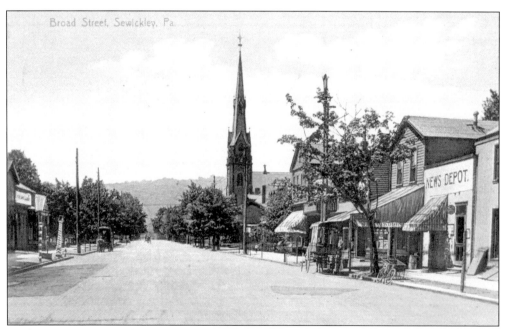

Broad Street, Sewickley, Pa.

Looking south toward the river and the bluff beyond, Broad Street is virtually deserted in this image taken before 1910, testimony to the quieter pace of those days. At that time, there was no bridge over the river or an Ohio River Boulevard. It is easy to see why the roadway is known as Broad Street.

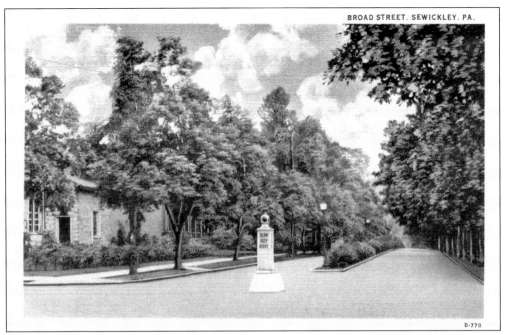

Sewickley has always put its best foot forward on Broad Street, as demonstrated by this view looking south from the Thorn Street intersection. At left is the Sewickley Public Library, erected in 1923. A median and the traffic marker indicate that this card dates from the 1930s.

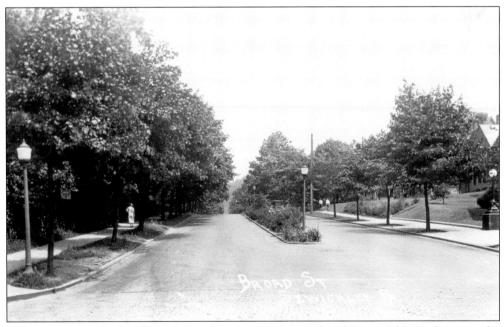

This card, postmarked 1935, looks north at the entrance to Broad Street. This is what a traveler turning into Sewickley from the newly constructed Ohio River Boulevard would have seen, and the view is much the same today, with the old post office building just out of the picture to the right. Broad Street was completely renovated and replanted in 2005.

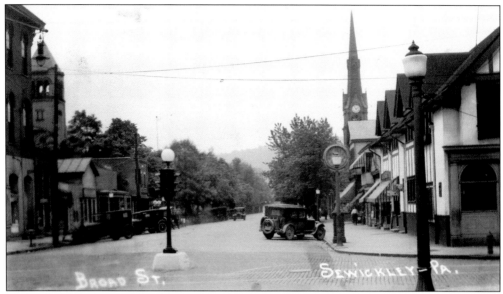

There is a traffic light right in the middle of the main intersection of Sewickley, Beaver and Broad Streets, in this *c.* 1940 view. The Tudor-style building on the right, remodeled by Earl M. Myers, was designed by Herman A. Lord of Ambridge, who had worked for Rutan and Russell. On the left is Mozart Hall, destroyed by fire in 1942, today the site of Wolcott Park. Beyond is the tower of the old yellow brick Sewickley Public School.

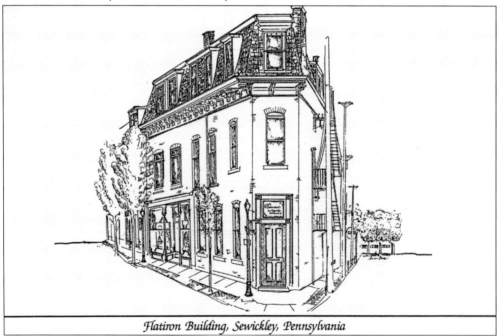

Flatiron Building, Sewickley, Pennsylvania

This drawing by Susan Gaca depicts Sewickley's Flatiron Building, at the intersection of Beaver and Division Streets. It is on a triangular lot because Division is a north-south street based on the survey of 1785, and all the rest of the streets in the town were laid out on a grid parallel with the river. It was, for a time, headquarters of the Sewickley Herald, the town newspaper founded in 1903. Today it is home to an art gallery.

This card, postmarked 1906, reads, in part, "This is Papa's place of Business & his youngest is in front of the store," signed Edythe Hutchinson. The Sewickley Cut Flower Company was located at 441 Beaver Street. The 1906 *Suburban Directory* lists a Frank W. Hutchinson, florist, with a home address at 518 Centennial Avenue, and a Robert W. Hutchinson, florist, with his home at 504 Bank Street.

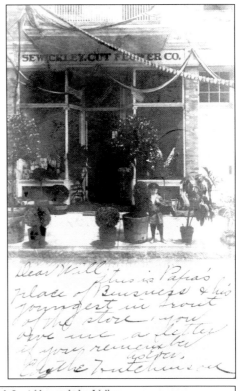

Captains of commerce formed the Sewickley Valley Business Men's Association, a forerunner of the Sewickley Chamber of Commerce. One of the objectives of the association was to unite the municipalities of the Sewickley Valley, a long-held dream yet to be brought to fruition. This card reproduces a photograph from a 1907 *Pittsburgh Gazette Times* advertisement entitled "Scenes in Sewickley and Its Prosperous Valley."

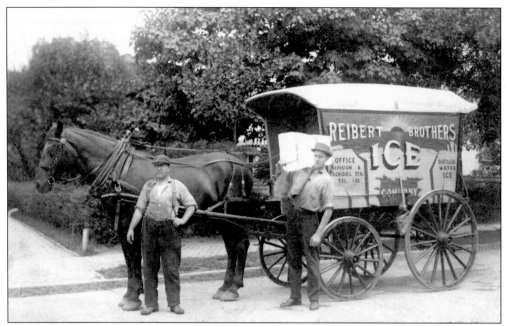

The Reibert Brothers were sons of John Reibert, a German refugee who opened a grocery store on Beaver Street in 1869. The store also provided ice from sources as far away as Lakes Conneaut and Chautauqua. In 1909, the Reiberts built a plant below the railroad, making ice from well water. The business closed in 1942. Notice the backward tilt to the men's posture from carrying all that heavy ice.

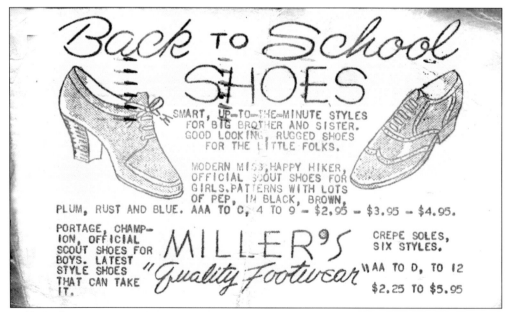

Miller's Shoe Store served the town for many years from several locations before eventually going out of business in the 1990s. This is an advertisement from the late 1930s.

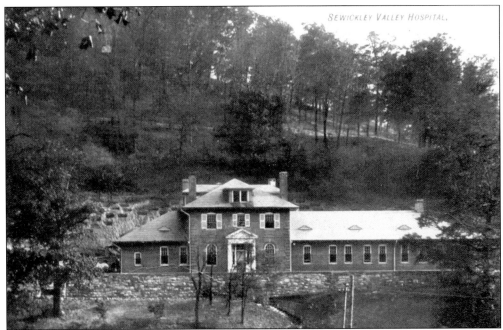

Sewickley's health care was greatly improved by the dedication of this building containing 14 beds on July 27, 1907. During its first year, the Sewickley Valley Hospital treated 168 patients. The hospital was built on four acres of hillside property overlooking Blackburn Road donated by Mrs. Henry W. Oliver. Today this is the site of the School of Nursing, constructed in 1960.

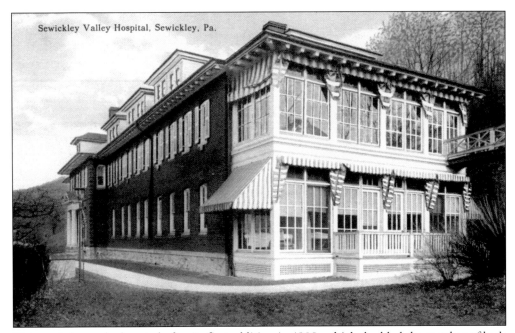

This card shows the hospital after its first addition in 1909, which doubled the number of beds from 14 to 28.

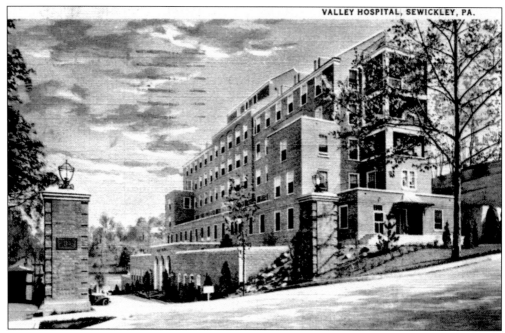

The hospital was called Valley Hospital when it opened on its current site in 1929. The main entrance was on Blackburn Road, across from the YMCA. A new laboratory building and north wing were added to the hospital in 1954; a parking deck and additional floors on a south wing were built in 1975. Today the main entrance is on Broad Street.

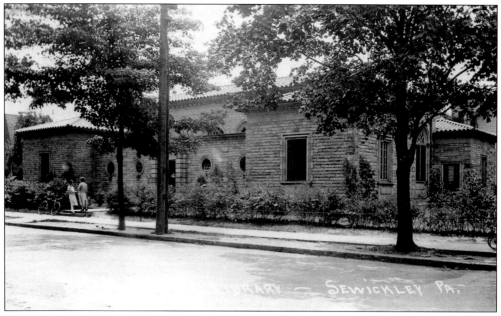

The Young Men's Library Association was established in Sewickley in 1873. In 1880, the library moved into the Sewickley Public School building, and on June 26, 1923, the present library was dedicated. It was a gift of William L. Clause, president of Pittsburgh Plate Glass Company, as a memorial to his wife, and was designed by architect Henry D. Gilchrist. It stands on the corner of Thorn and Broad Streets.

The Sewickley Public Library has been connected since 1880 with the schools of the valley. Today the Quaker Valley School District provides the majority of its annual operating budget, and the service area of the library has been expanded to cover the 11 municipalities encompassed by the school district. A major renovation and expansion of the library was completed in 1999. This drawing is by Susan Kilmartin.

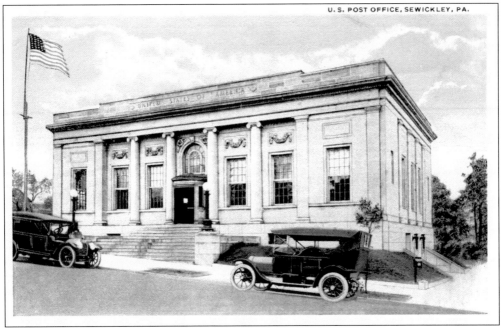

The first post office in the region was at Newington, the home of David Shields in Edgeworth, and was called Sewickley Bottom. After that office closed in 1857, Sewickley mail was delivered to various places in the village. This handsome Beaux Arts edifice on Broad Street at the entrance to Sewickley, designed under the supervision of James Knox Taylor, was dedicated in 1912.

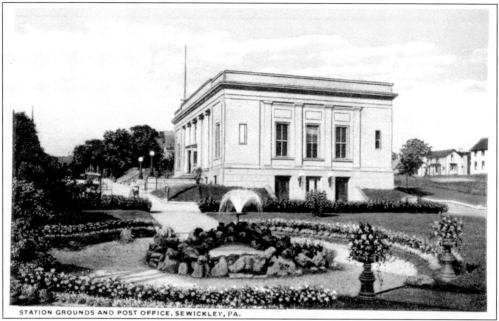

STATION GROUNDS AND POST OFFICE, SEWICKLEY, PA.

The old Sewickley Post Office was conveniently located immediately adjacent to the railroad station, at the foot of Broad Street. The Pennsylvania Railroad maintained extensive gardens, as can be seen from this postcard from before 1929, when the railroad tracks and the station were moved closer to the river. The Ohio River Boulevard extended this far by 1934.

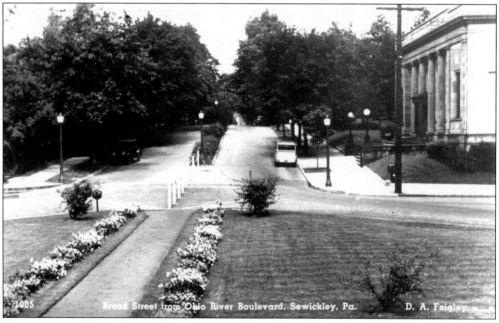

Broad Street from Ohio River Boulevard, Sewickley, Pa. D. A. Feigley

This postcard of Broad Street, looking toward Sewickley Village from Ohio River Boulevard, shows the old post office on the right. Phased out after the construction of a new Sewickley Post Office in 1981, the building was acquired by the Old Sewickley Post Office Corporation and reopened in 1987 as a cultural center. It is now home to Sweetwater Center for the Arts and the Sewickley Valley Historical Society.

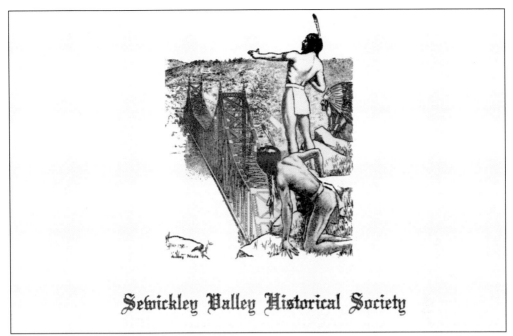

Sewickley Valley Historical Society

The Sewickley Valley Historical Society, housed in the old Sewickley Post Office building, was founded in 1973. Its mission is to promote interest in and to record, collect, preserve, and document the history of the Sewickley Valley. This postcard shows the historical society's logo, the 1911 Audley Nicols drawing of American Indians looking over the first Sewickley Bridge.

Founded in a house on Thorn Street in 1974, Sweetwater Art Center (later renamed Sweetwater Center for the Arts) moved into the old Sewickley Post Office building when it was converted to a cultural center in 1987. This postcard promoted a series of post office–related activities sponsored by Sweetwater in 2003, celebrating the 150th anniversary of Sewickley's incorporation.

53

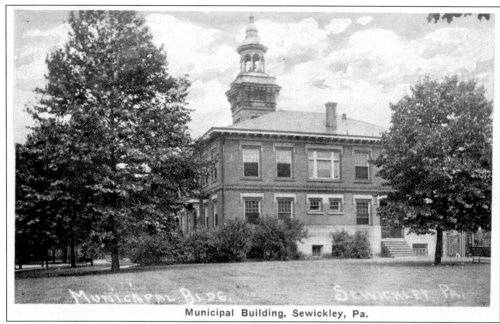

Municipal Building, Sewickley, Pa.

Sewickley's municipal building, dedicated March 1910, is credited to architect C. W. Bier. It is actually a modification of an earlier plan featuring two square towers drawn by Sewickley architect Elmer E. Miller, designer of the 1894 Sewickley Public School, which also featured a strong square tower. The building, constructed of red brick and Cleveland sandstone with a 90-foot tower, stands on Thorn Street, between Chestnut and Logan Streets.

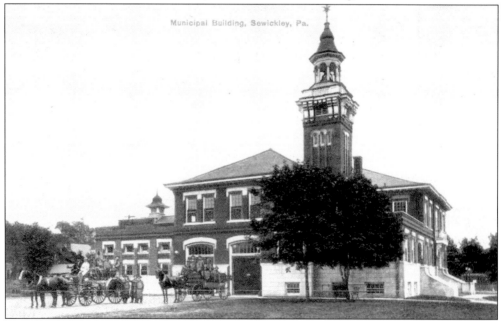

The Cochran Hose Company, Sewickley's volunteer fire department, was organized at a public meeting in 1876 in Mozart Hall. It has been housed in the Sewickley Municipal Building since its construction in 1910. This card shows the Chestnut Street facade of the building, with horse-drawn fire wagons at the ready. The building was renovated in 1984 to make room for modern fire equipment.

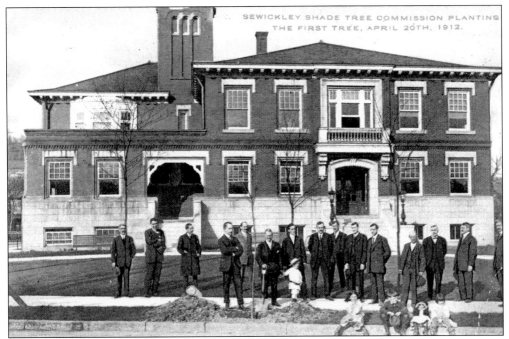

This view of the municipal building from Thorn Street shows officials of the Sewickley Shade Tree Commission planting the first tree on Arbor Day, April 20, 1912, for an audience of approving children.

In 1859, 22 acres above the town were acquired for a cemetery. Engineering a roadway to the site was challenging, but the vista is inspiring. The cemetery was opened formally on November 1, 1860, and the ensuing Civil War meant the cemetery began to fill up rather more quickly than anticipated. In 1866, a monument was raised there to commemorate the sacrifice of Sewickley boys during the conflict.

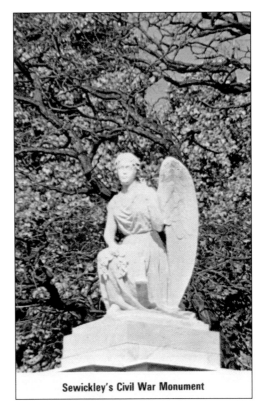

Sewickley's Civil War Monument

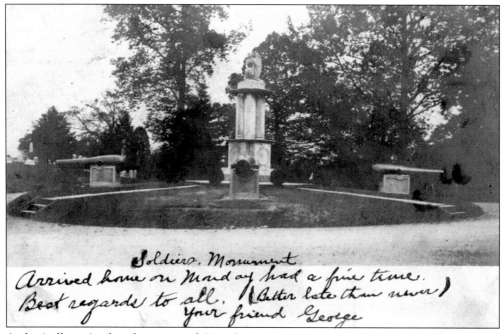

Soldiers, Monument
Arrived home on Monday had a fine time.
Best regards to all. (Better late than never)
Your friend George

A classically trained sculptor named Isaac Broome won a competition to carve the soldiers' monument in marble, a life-sized, heroic statue of Fame, who, seeking a place from which to sound her trumpet in praise of noble sacrifice, has alighted on a small Ionic temple. In 1906, the government donated four 10-inch Rodman cannon to enhance the site. These cannon were removed for use as scrap metal during World War II.

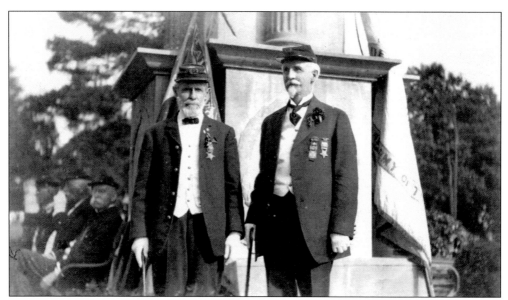

Two Civil War veterans, Albert Moore and W. W. Scott, pose for the camera in front of the statue of Fame on Decoration Day, May 30, 1915. The community has sponsored a parade and ceremonies at the soldiers' monument in Sewickley Cemetery since 1880. In 2005, the badly deteriorated marble monument was entirely replaced in granite, which will last indefinitely.

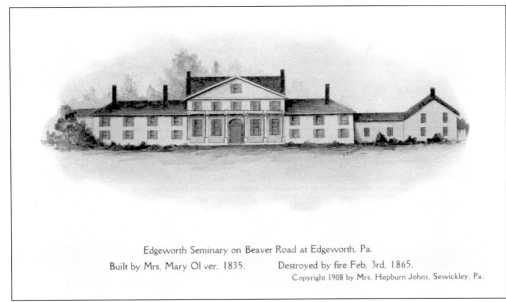

Edgeworth Seminary on Beaver Road at Edgeworth, Pa.

Built by Mrs. Mary Olver, 1835. Destroyed by fire Feb, 3rd, 1865.

Copyright 1908 by Mrs. Hepburn Johns, Sewickley, Pa.

The borough of Edgeworth got its name from the Edgeworth Female Seminary, named for Anglo-Irish author Maria Edgeworth by her fellow countrywoman Mary Gould Olver. Visiting Newington in Sewickley Bottom, the home of two of her students, Hannah and Rebecca Shields, Olver was impressed by the natural beauty of the valley as well as its accessibility to Pittsburgh and moved her school here from Braddock, Pennsylvania, in 1836.

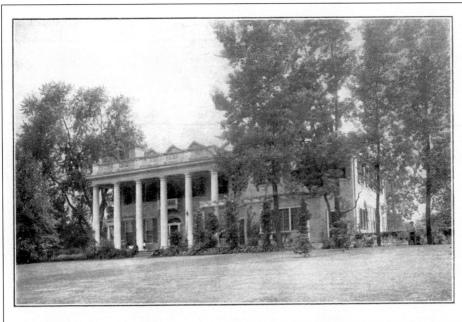

Edgeworth Seminary on Beaver Road, burned 1865, rebuilt after the fire. Later remodeled and enlarged by J. Wilkinson Elliott, now his residence at Edgeworth, Pa., 1908.

By 1838, the Edgeworth Female Seminary had 74 pupils, most from the Pittsburgh area. Pres. Zachary Taylor made a memorable visit there in 1848 during a journey west. The original structure burned in 1865 and was rebuilt for use as a private residence. Architect J. Wilkinson Elliott added the majestic, columned portico and the wing to the right after he acquired the property in 1903. The building still stands today.

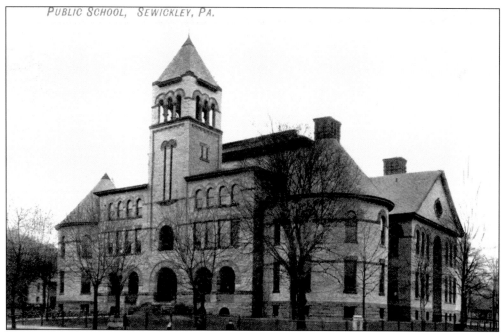

The Richardsonian Romanesque Sewickley Public School, affectionately known as the yellow brick school, was designed by Elmer E. Miller and dedicated in 1894, replacing an 1862 building on the same site that burned in 1893. From 1834 to 1848, the old log church on Division Street served as a school, followed by a brick building on Locust and Crooked Streets (now Centennial Avenue and Hegner Alley).

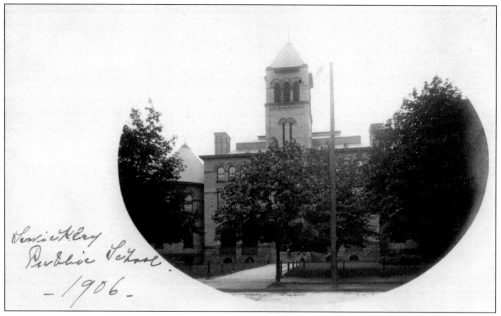

The yellow brick school, which dominated the village scene on Broad and Thorn Streets, became the Sewickley Elementary School after the new Sewickley High School was dedicated in 1926. It was razed in 1975, when consolidation of several elementary schools by the Quaker Valley School District rendered it obsolete.

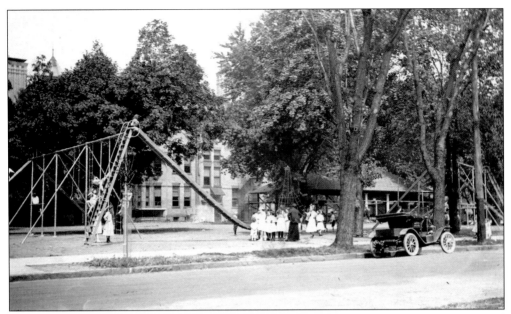

This postcard, dated September 1, 1913, shows the playground of the Sewickley Public School from Chestnut Street. Note the height of the slide. That little girl is certainly brave! The vehicle to the right has "West Penn" on its side.

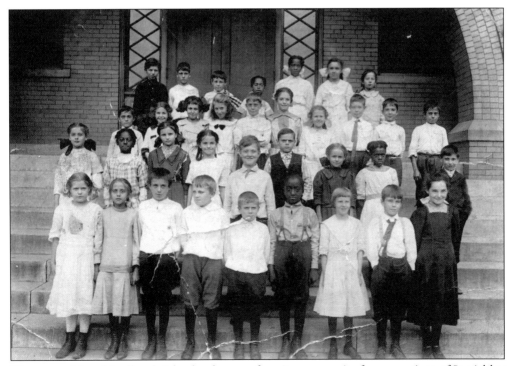

The steps of the old yellow brick school were a favorite camera site for generations of Sewickley school children. Here are students posed in front of the main entrance arch.

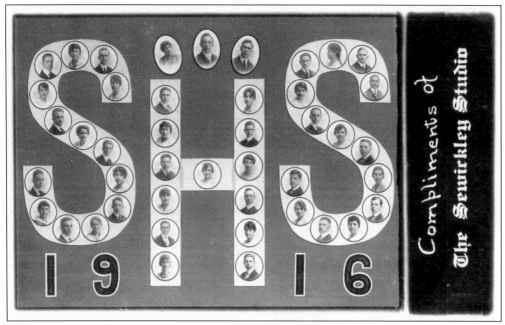

Diplomas for the 1916 graduating class of Sewickley High School were handed out in the yellow brick building on Broad Street. After 1926, the high school was located in a new building on Harbaugh Street.

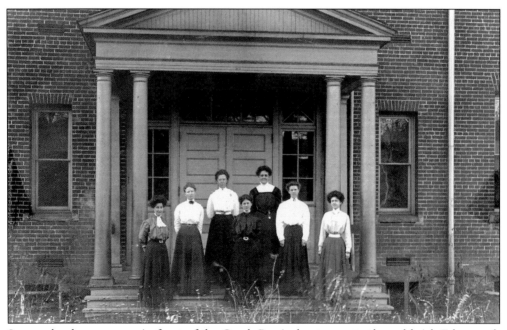

Seven schoolmarms pose in front of the Greek Revival entrance to the red brick Edgeworth Public School, built in the 1890s and razed in 1975. The school stood on Beaver Road, where the playground of Quaker Valley's Edgeworth Elementary School is today.

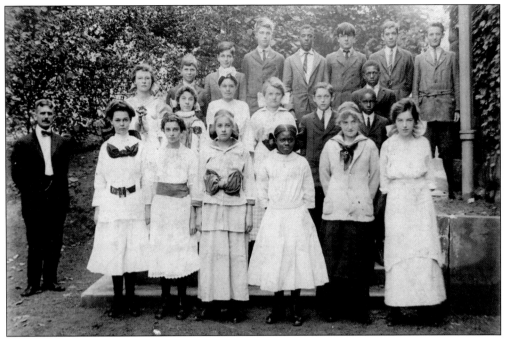

This postcard shows the graduating class of the Edgeworth Public School in 1915. The school served both elementary and junior high students. Frederick Way Jr. can be seen at the left in the top row. He was to become a steamboat captain, an expert on American rivers, and an accomplished writer.

Students and teachers pose in front of the Osborne Public School. Osborne's first schoolhouse was a one-room school located north of Beaver Road and east of the present Glen Mitchell Road. A new brick building was constructed in 1890, serving children from Osborne and some of the neighboring boroughs. That building is shown here.

In use 80 years, the Osborne School was heavily damaged by fire in 1970. The children moved to elementary schools in Sewickley and Glenfield until 1975, when a new Osborne Elementary School of the Quaker Valley School District was constructed. The old school building, which still stands across from yet another new school, was bought and renovated by Grace Orthodox Presbyterian Church and dedicated in 1972.

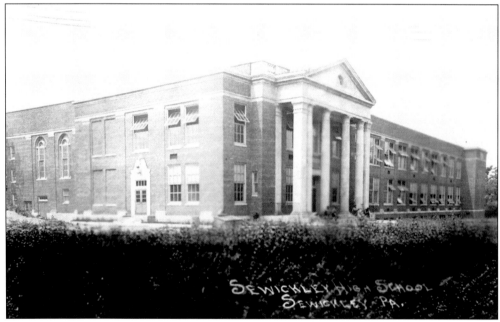

This postcard shows the new Sewickley High School, on Harbaugh and Graham Streets, designed by P. C. Dowler. The editor in chief of the 1926 *Sewihi*, the high school yearbook, said that the students had truly passed from "log cabin to the White House." The building is now the Quaker Valley Middle School.

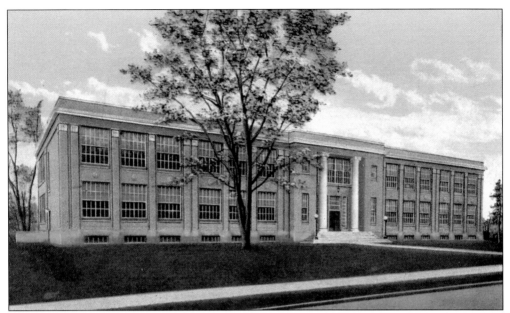

Leetsdale High School, opened in 1926 on Beaver Street, became Quaker Valley High School in 1956. In that year, the Quaker Valley Joint School District was formed, today consisting of 11 municipalities: Aleppo, Bell Acres, Edgeworth, Glenfield, Haysville, Leet, Leetsdale, Osborne, Sewickley, Sewickley Heights, and Sewickley Hills. Before that time, Leetsdale High School and Sewickley High School were traditional rivals.

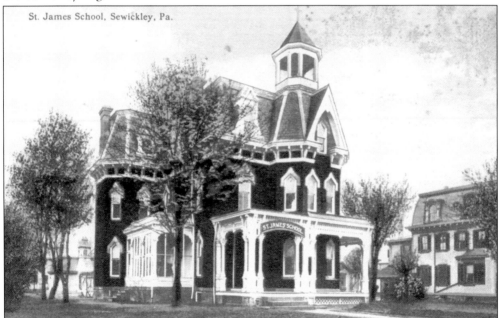

The first school building of St. James Parish was dedicated in 1913, with an enrollment of 80 students. The three-story, late-19th-century mansion on Broad Street was purchased from D. C. Herbst. The bell and tower seen in this card were added and have since been removed. Later used as a convent, the building is still owned by the church. The new St. James School was dedicated in 1954.

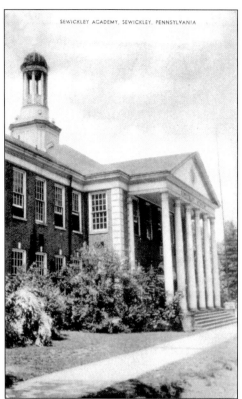

This grand Georgian building capped by a bell tower, the fifth home of Sewickley Academy, was designed by architect William Meanor and opened in 1929. A major fire in 1970 severely damaged the structure, but this symbol of the Sewickley Valley's educational heritage was soon rebuilt. Sewickley Academy, today coeducational, was founded in 1838 by William H. Nevin and John B. Champ as a "Classical and Commercial School for Boys."

The Sewickley Valley was home to many one-room schools, including Friday, Jenny, Watson, Blackburn, Magee, Haysville, and Glen Mitchell. Here are students with their teacher at another one-roomer, the Water Works School, in the second decade of the 20th century. Presumably the children are costumed for Halloween.

Although summertime worship took place in Addy Beer's Grove, near where the YMCA now stands, Presbyterian and Methodist services were held in this 1818 log church on Division Street until 1834. Used as a schoolhouse until 1846, the building was moved to Fife Street (now Blackburn Road), where it became a carpenter shop and the town's first undertaking establishment. It was demolished in 1876 when Centennial Avenue was opened.

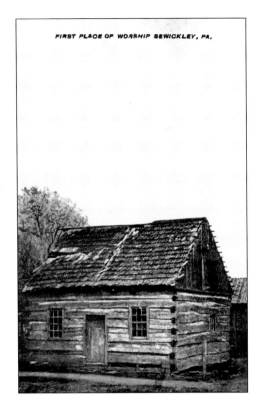

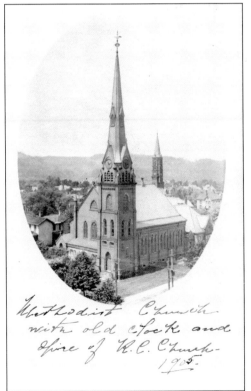

The location of the Sewickley United Methodist Church, organized in 1839, testifies to the importance of the denomination in Sewickley. Its members included the earliest settlers of the valley. This building was the second erected on the site. Its cornerstone was laid in 1882, and the structure was dedicated in 1884. The architect was James P. Bailey. The spire in the background belongs to the old St. James Church.

Here is another view of the Methodist church, located at Broad and Thorn Streets at the exact geographic center of Sewickley Village. Its bell tower houses the official town clock, purchased in 1883 from the E. Howard Clock Company of Boston. The clock was converted to electricity in 1919 and has been lighted since 1949.

In 1840, the Presbyterians built a brick sanctuary, designed by John Chislett in the Gothic style, directly across Beaver Street from the location of this building. This picturesque structure of native sandstone was designed by J. W. Kerr and constructed from 1859 to 1861. Subsequent additions include an 1864 chapel by Barr and Moser, a 1914 parish hall by Rutan and Russell, a 1953 chapel by J. Philip Davis, and in 1996, an addition to the parish hall by MacLachlin, Cornelius and Filoni.

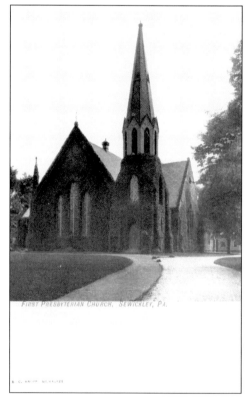

FIRST PRESBYTERIAN CHURCH, SEWICKLEY, PA.

Before the sanctuary of The Presbyterian Church of Sewickley was dedicated in 1861, the Sewickley Rifles practiced drilling there prior to leaving to fight with the 28th Regiment in the Civil War. The bell in the church tower was a gift of Cochran Fleming, owner of substantial real estate in the area.

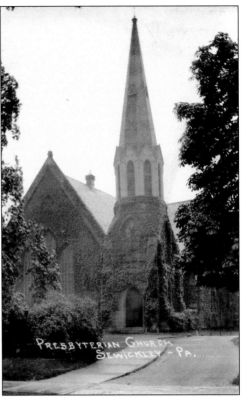

Standing on principle in 1864, conservative Presbyterians, opposed to the installation of an organ in the Sewickley Presbyterian Church and troubled by other issues, formed St. Andrew's United Presbyterian Church. Property was acquired on Broad Street, next door to the Methodists, where the congregation worshipped until the construction of the present edifice on Beaver Street.

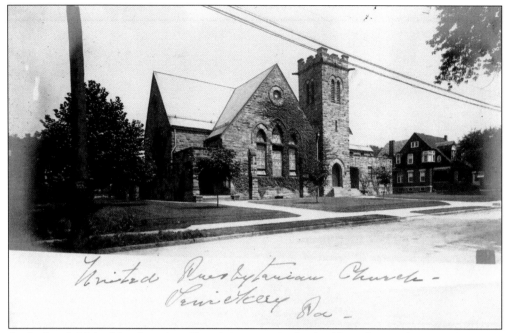

*United Presbyterian Church -
Sewickley Pa -*

St. Andrew's United Presbyterian Church is a neo-Gothic building designed in 1896 by Elmer E. Miller, a member of the congregation. Miller also designed Sewickley's beloved yellow brick school and did preliminary drawings for the Sewickley Municipal Building.

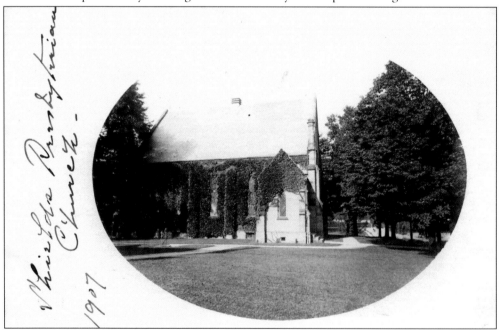

Shields Presbyterian Church - 1907

Shields Presbyterian Church, originally Leetsdale Presbyterian Church, was dedicated in 1869. This side view of the building was taken in 1907, the year the name was changed. The Gothic Revival structure, located on Beaver Road and Church Lane in Edgeworth, was a gift of Eliza Leet Shields. The building contains stained-glass windows dedicated to Daniel Leet, a soldier in the American Revolution, and his wife, Wilhelmina, parents of the donor.

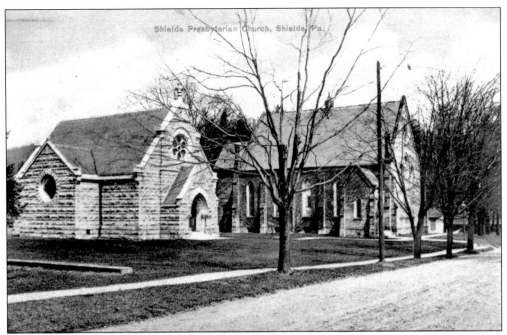

More than 30 members of the Shields family are interred in the Shields Mausoleum, built in 1893 on Church Lane alongside the Shields Presbyterian Church. The Romanesque structure is attributed to architect John U. Barr. Leadership for this project came from David Shields Wilson, a grandson of Eliza Leet Shields, donor of the Shields Church.

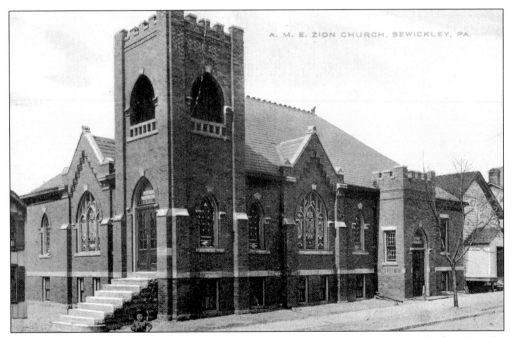

Daniel B. Matthews, a circuit-riding minister descended from a Prussian soldier who fought in the American Revolution, is credited with initiating Sewickley's African Methodist Episcopal Zion Church mission shortly after the Civil War. This church building was constructed in 1912.

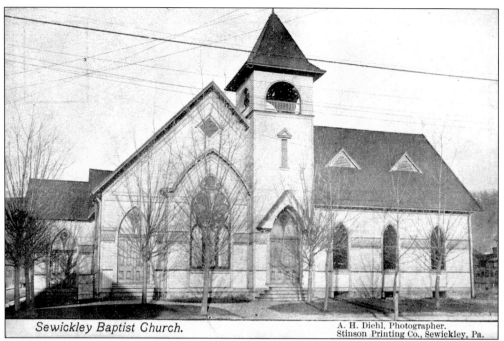

Sewickley Baptist Church.

Sewickley Baptist Church, designed by architect Charles Cooper and dedicated in 1889, is located at the corner of Beaver and Grimes Streets. This photograph was taken by Aaron Hayden Diehl, who was Sewickley's best-known photographer for more than four decades. The Stinson Printing Company, publisher of this postcard, began publication of the town's newspaper, the *Sewickley Herald*, in 1903.

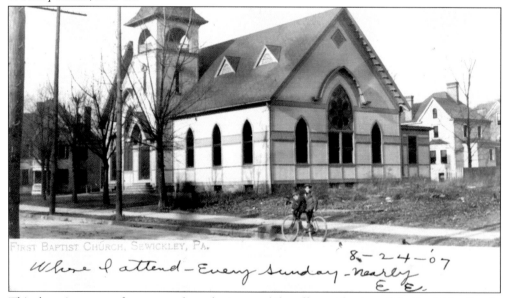

FIRST BAPTIST CHURCH, SEWICKLEY, PA.

Where I attend – Every Sunday – nearly 8 – 24 – '07
E. E.

This charming scene of two young boys sharing one bike offers a side view of the Sewickley Baptist Church. The card, dated August 24, 1907, bears the message "I attend every Sunday - nearly." This congregation was organized in 1873 by Baptists who worshipped in Old Allegheny. Andrew Carnegie gave an organ to the church in 1902, the last of the organs that the philanthropist presented outright to churches.

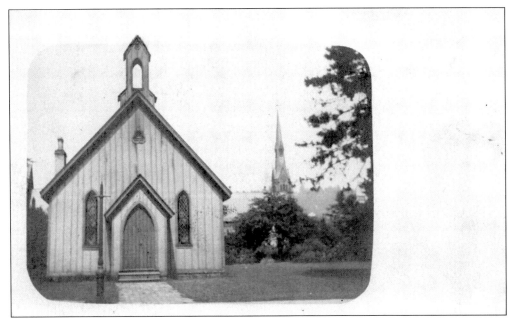

The first sanctuary of St. Stephen's Episcopal Church was this small board-and-batten Gothic Revival structure that stood on Broad Street and Vine Street (now Frederick Avenue) beside the old parish house and school. The building was designed and planned by the Rev. P. Ten Broeck, the first minister of St. Stephen's. Ground was broken in 1863, and the church was consecrated on May 28, 1864.

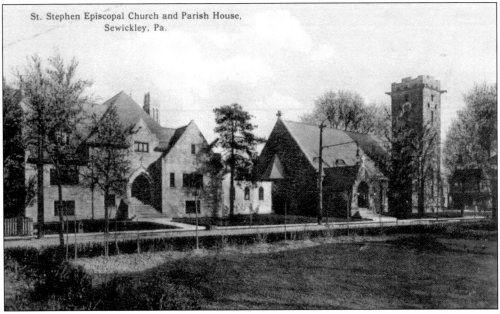

A new St. Stephen's Episcopal Church was designed by architects Bartberger and East and opened in time to celebrate Christmas in 1894. Beside the sanctuary, facing Broad Street, the congregation erected a parish house in 1912. When that building was destroyed by fire in 1914, local architects Alden and Harlow were engaged to replace it. This is a view of the new church complex from Frederick Avenue.

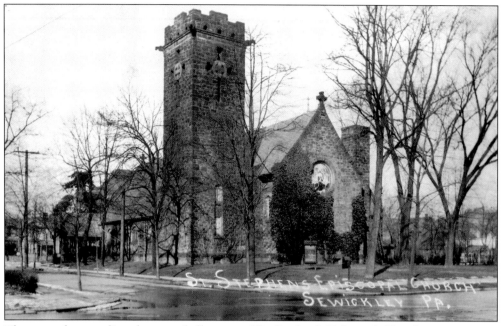

The gargoyles guarding the stone bell tower of St. Stephen's Episcopal Church were a source of wonder to the students of Dr. Robert A. Benton's parish school, which was located across Frederick Avenue. Dr. Benton was rector of St. Stephen's. This postcard, postmarked 1931, shows the church from Broad Street.

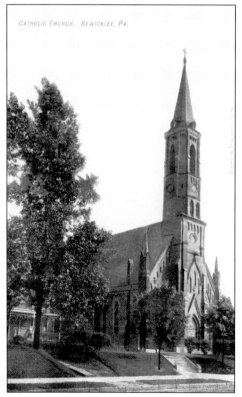

St. James Roman Catholic Church on Walnut Street was dedicated on Thanksgiving Day, November 24, 1870. It would have opened more than a year earlier, but on May 12, 1869, the nearly completed structure collapsed after a severe windstorm hit the area. The well-loved old St. James served the parish until 1967. It was razed when the present sanctuary was consecrated.

Three

QUEEN OF THE SUBURBS

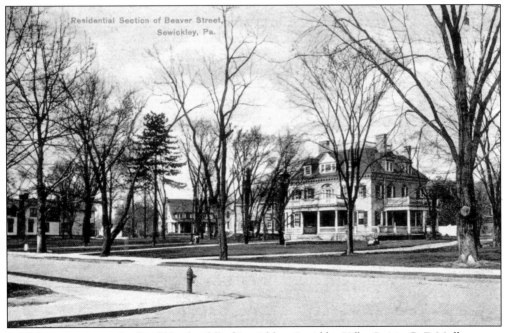

In his introduction to the first "blue book" of Sewickley, *Sewickley Valley Society*, G. F. Muller wrote in 1895, "To this favored section can truthfully be applied the term Queen of Suburbs . . . certainly the most delightful residence spot in Western Pennsylvania." Shown here at right is Wisteria, the home of Edward O'Neil, a Colonial Revival house designed in 1894 by architect Frank Rutan, O'Neil's friend and neighbor.

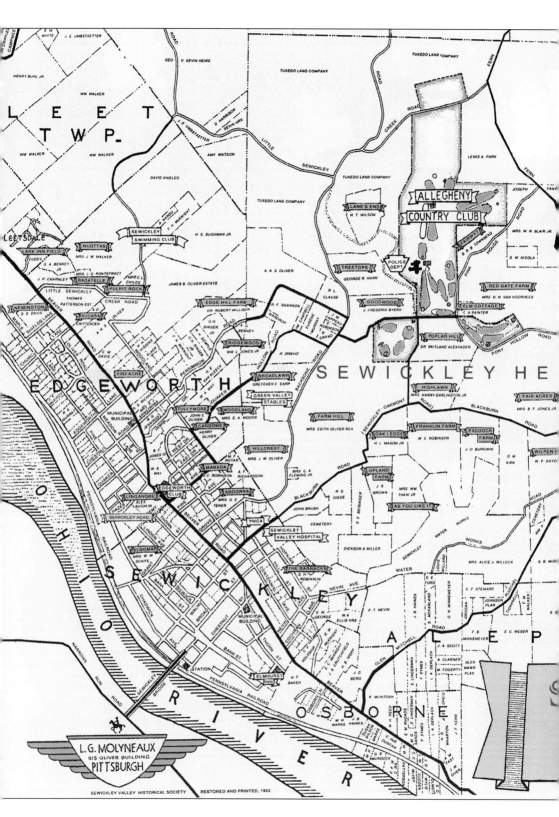

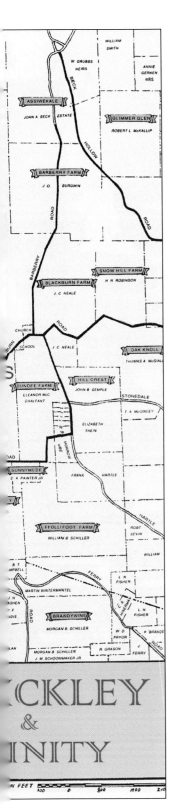

WILLIAM SMITH

W GRUBBS HEIRS

ANNIE GERKEN MRS

ASSIWEKALE

JOHN A BECK ESTATE

GLIMMER GLEN

ROBERT L McKALLIP

BARBERRY FARM

J O. BURGWIN

SNOW HILL FARM

H H ROBINSON

BLACKBURN FARM

J. C. NEALE

CHURCH

SCHOOL

J C NEALE

OAK KNOLL

THOMAS A McGINL

DUNDEE FARM

ELEANOR McC CHALFANT

HILL CREST

JOHN B SEMPLE

STONEDALE

T A McGINLEY

ELIZABETH THEIN

SUNNYMEDE

C A PAINTER JR

FRANK HARTLE

FFOLLIFOOT FARM

WILLIAM B SCHILLER

ROBT SEVIN

WILLIAM

B T MPBELL

MARTIN WINTERMANTEL

L N FISHER

J N ASHEN

F DIS

BRANDYWINE

MORGAN B SCHILLER

L N FISHER

W D PRYOR

P BRANDE

LAN

MORGAN B SCHILLER
J M SCHOONMAKER JR

R GRASON

J FERRY

CKLEY

&

NITY

N FEET

This is an adaptation of a map first produced in the mid-1930s by Pittsburgh cartographer Laurence Greer Molyneaux. It shows the municipalities that make up the Sewickley Valley as well as many of the landmark buildings and estates in the area.

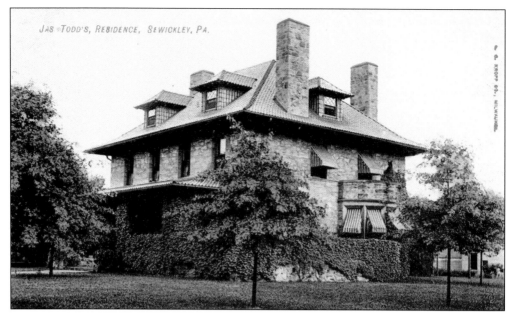

Built like the Rock of Gibraltar is this Sewickley house designed by Rutan and Russell for James S. Todd, owner of the Sterling Varnish Company in nearby Haysville. Occupying a prominent location at the corner of Beaver Street and Academy Avenue, the house has many interesting interior features, particularly the elaborate woodwork. A handsome carriage house enhances the Academy Avenue view.

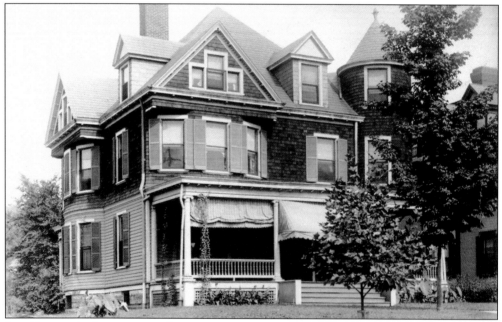

Standing on the busy corner of Beaver Street and Academy Avenue in Sewickley, this house is listed in 1906 as belonging to Ada Nevin. It is an integral part of a group of late-19th- and early-20th-century houses that collectively contribute to Sewickley's character as a suburban retreat. Although the tower at the right of the building is gone, the house survives today as a private residence.

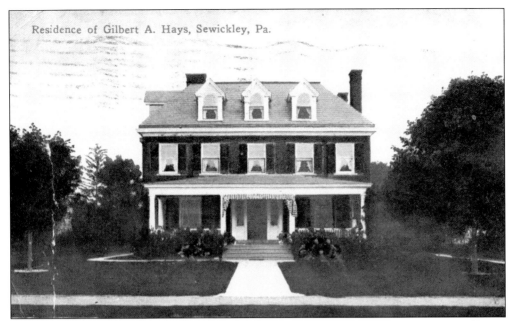

Residence of Gilbert A. Hays, Sewickley, Pa.

Academy Avenue was a busy neighborhood when Gilbert Hays built this Colonial Revival home in about 1900. Hays, publisher of a Sewickley weekly, was a son of Western Pennsylvania's Civil War hero Alexander Hays. He was in the forefront of civic affairs in Sewickley, calling the first meeting to push for the Sewickley Bridge. A garden party at this house was the first outdoor event in the town to be illuminated by electricity.

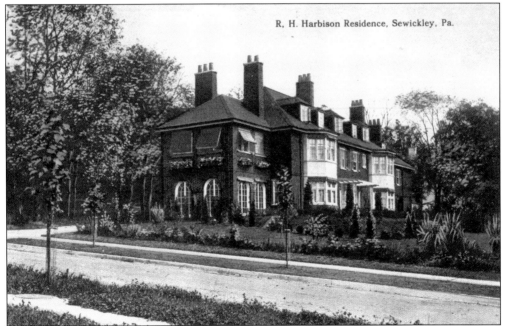

R. H. Harbison Residence, Sewickley, Pa.

Great for entertaining is this spacious brick house in the Tudor style designed for Ralph W. Harbison, not R. H. as this postcard suggests. The Pittsburgh firm of MacClure and Spahr designed the house, which still stands today on Pine Road in Sewickley. The Harbisons were lovers of music, and the Sewickley Symphony was founded here.

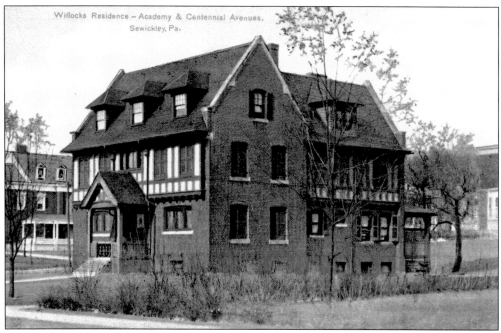

This 1896 house was built in the arts and crafts style for John S. Willock. The house, with its picturesque half-timbering, is attributed to architects Frank E. Rutan and Frederick A. Russell. It still stands along Centennial Avenue in Sewickley. The street, originally called Locust, was renamed and extended in 1876 to celebrate the 100th anniversary of the nation.

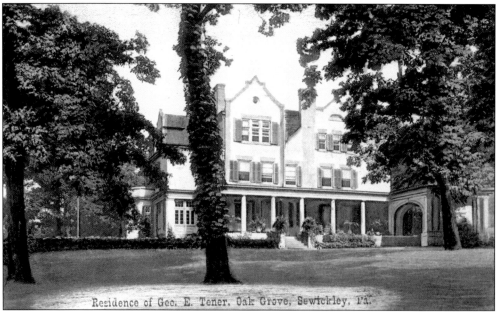

Long gone is this palatial home, originally built for Frank Biddle Smith, president of Crucible Steel, and called Oak Grove. It overlooked the Canterbury Lane area of today. Bought in 1908 by George Evans Tener, a native of County Tyrone, Ireland, the house was renamed Ardarra. Tener was in the iron and steel industry. His younger brother, John Kinley Tener, served as governor of Pennsylvania from 1911 to 1915.

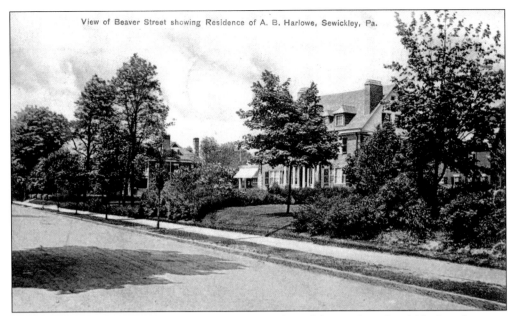

The Colonial Revival style was inspiration for an architect's home along Sewickley's main street. The publisher of this card with a 1910 postmark mistakenly added an "E" to the surname of Alfred Branch Harlow, principal of the firm of Alden and Harlow, designers of many fashionable Sewickley homes in the late 19th and early 20th century. Harlow began his career with the prestigious firm of McKim, Mead and White.

This postcard shows members of the Watson family in the front yard of their home at 818 Centennial Avenue, Sewickley. From this house in 1930 the first trans-oceanic telephone message was transmitted to Australia. Aided by Pittsburgh radio station KDKA, Francis Corry Watson and his brother Samuel talked together for the first time in 57 years. F. C. Watson's grocery at the corner of Chestnut and Beaver Streets was a Sewickley institution.

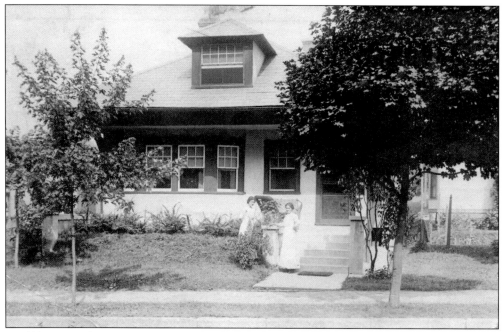

Small houses such as this bungalow are seldom featured on postcards. This house, at 731 Cochran Street, Sewickley, is still extant and is similar to another of the same era at 519 Nevin Avenue. The long, sloping roof, wide eaves, and broad front porch are characteristic of the Craftsman style, the most popular style for small houses in early-20th-century America.

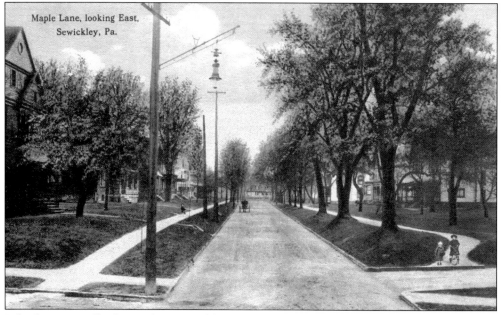

Suburbia was well advanced in Sewickley in 1912, as this view of Maple Lane looking east demonstrates. Not only did the residents enjoy a paved, tree-lined street, but children could ride their tricycles and push their doll buggies on the sidewalks. Even more important, the location, just a few minutes walk from the Sewickley railroad station and post office, made the street a prime address for commuters to Pittsburgh.

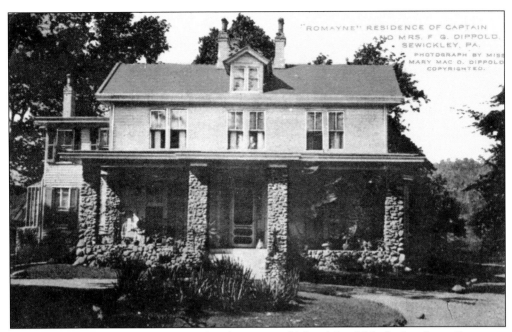

The romantic residence of Capt. Frederick G. Dippold faced Sewickley's riverfront. Romayne became the headquarters for friends made during his many years on the Ohio River. Daughters Mary and Louise, themselves licensed river pilots, were collectors like their father. He picked up American Indian artifacts; they liked antiques. Alas, the house, with columns of stones from around the world, was razed in 1927, when the railroad tracks were moved.

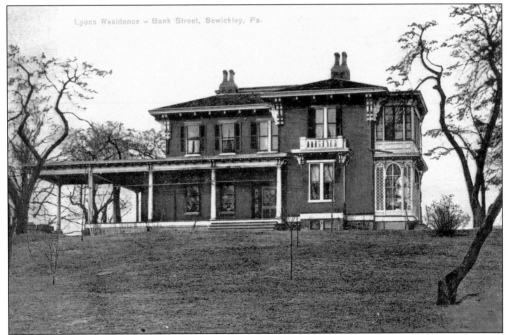

This house stood at 827 Bank Street, which bordered the Pennsylvania Railroad tracks before they were moved closer to the river. Called Casa Leon, it was the home of attorney Walter Lyon and his family. The house no longer stands.

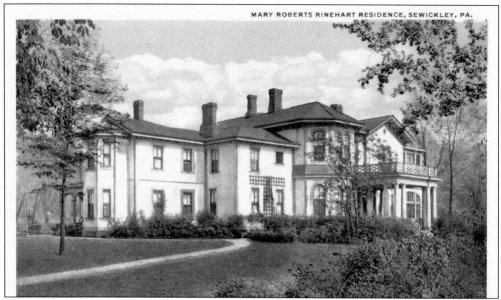

Beginning in 1911, this rambling house in Osborne Borough was the home of mystery writer Mary Robert Rinehart. Rinehart's success was well established when she acquired the house, built in 1863 for railroad magnate George W. Cass. It was originally called Cassella, but the Rineharts renamed it The Bluff. The author and her family took an active part in civic and social life before moving to Washington, D. C., in 1921. The house was razed in 1969.

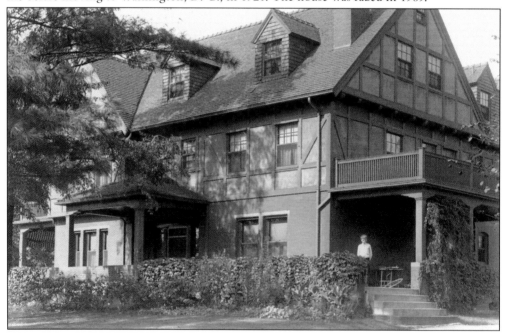

This massive Tudor Revival house, which incorporates some aspects of the early arts and crafts movement, was commissioned in 1894 by Charles McKnight Jr. Both McKnight and his wife, Eliza, were Pittsburghers with close ties to Sewickley. Alden and Harlow were the architects of the mansion, which sat on 10 acres of landscaped gardens along Beaver Road in Osborne Borough. It is still extant.

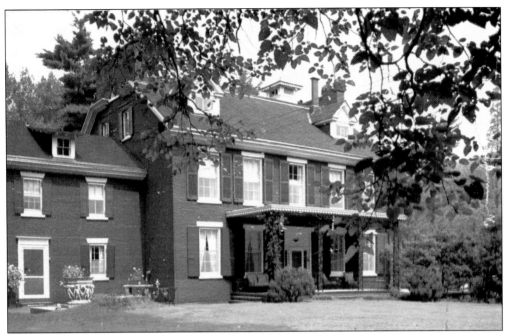

Sewickley Valley history and Newington go hand in hand. This plantation-style house is located along Beaver Road in Edgeworth Borough. Members of the David Shields family have been in residence since construction was begun in 1816. Newington's first mistress was Eliza Leet Shields, daughter of Maj. Daniel Leet, who served with Washington at Valley Forge and who surveyed the Sewickley Valley after the Revolution.

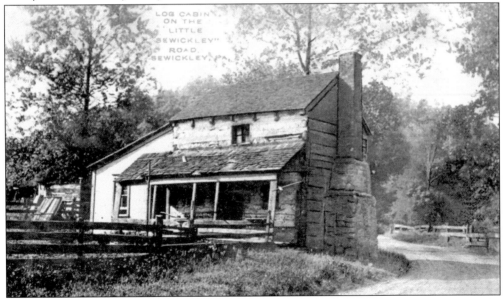

This cabin along Little Sewickley Creek was a longtime landmark in Walker Park, Edgeworth. The original owner of the property was Daniel Leet, and the cabin was probably built for him. It later became identified with the family of a member of Gen. Anthony Wayne's legion and was known locally as Peters' Cabin or, sometimes in jest, as Peters' Palace. Because of vandalism, it was sold and moved to private property in the 1970s.

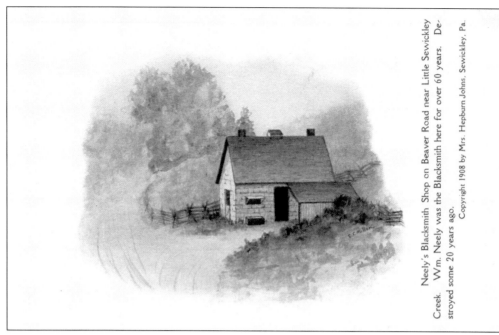

The blacksmith was a necessary participant in the life of the 19th century. For more than 60 years, William Neely catered to travelers on the Beaver Road. The smithy worked in this small building along the Little Sewickley Creek until 1888. Although his shop is gone, Neely's house, built around 1816, remains as a private residence.

The owner of this Edgeworth house acquired his wealth through ownership of a Pittsburgh firm that sold Old Satisfaction coffee. Jehu Haworth bought the home on Woodburn Terrace as a summer place, but Mosscroft eventually became the family's permanent residence. The Haworths were known for their participation in fund-raising theatricals to benefit good causes and for their son J. Fred, whose aerial photographs, taken from a kite, predated the invention of the airplane.

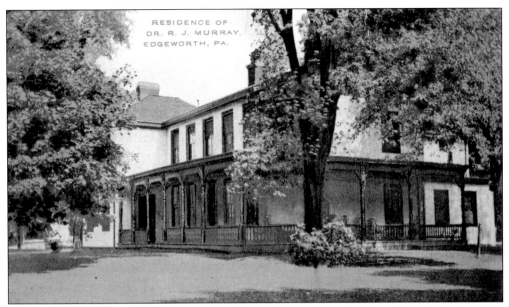

RESIDENCE OF
DR. R. J. MURRAY,
EDGEWORTH, PA.

This comfortable home of Dr. R. J. Murray along Edgeworth's Woodburn Terrace was just what the doctor ordered. Built by John Woodburn, a riverboat captain, it offered a splendid view of the Ohio River and the hills beyond. During Dr. Murray's residency, it also offered easy access to Pittsburgh on the frequent trains of the Pennsylvania Railroad. The house, with its main entrance from Maple Lane, stood until the 1950s.

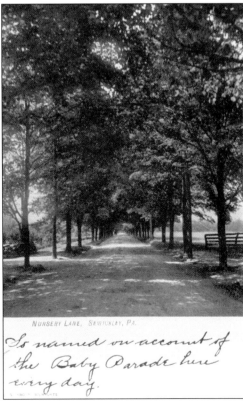

NURSERY LANE, SEWICKLEY, PA.

So named on account of the Baby Parade here every day.

This card showing Nursery Lane, Edgeworth, with the message "So named on account of the Baby Parade here every day," indicates that, although a keen observer of the everyday scene, the writer knew little of local history. While it is true that nurses liked to wheel babies along this tree-lined street, the place actually takes its name from the greenhouse-nursery that operated nearby. Today it is Maple Lane.

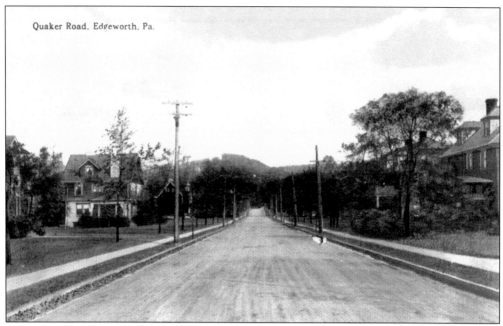

Quaker Road, Edgeworth, Pa.

In the first decade of the 20th century, the Way family developed a portion of its Edgeworth land along Quaker Road. Several houses were built by this founding family, some with brick salvaged from the demolition of the old Way Academy, a three-story structure that stood on the corner of Beaver Road and Academy Avenue.

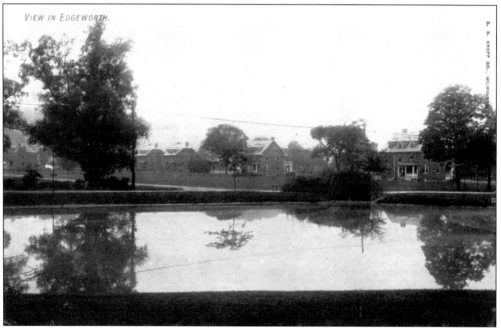

VIEW IN EDGEWORTH.

Before it was drained in the 1920s, Edgeworth boys could sail their toy boats on this pond. Way Pond triangle, today's Way Park, remains a natural gathering place and a favorite background for wedding photographs. This scene, looking toward the Ohio River, shows houses the Way family built on Quaker Road.

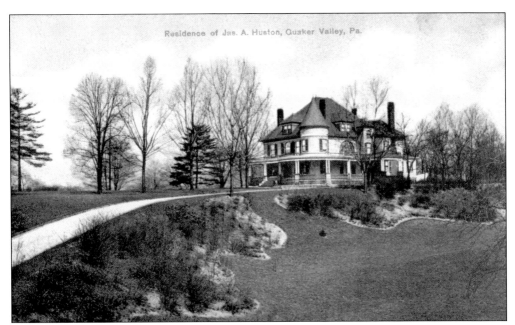

History surrounds this mansion located near the old Quaker Valley station in Edgeworth. It was the home of James A. Huston, an official of the American Bridge Company. In 1904, the first official meeting of Edgeworth Borough was held here. In the late 1920s, it was acquired by Sewickley Academy. The house was razed in 1929 to make way for the academy's main building.

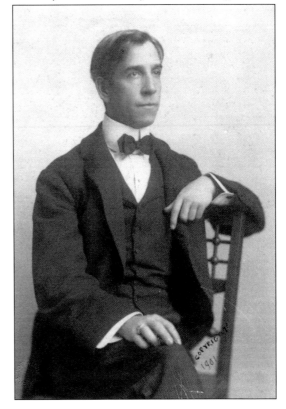

Ethelbert Woodbridge Nevin (1861–1902) was born into a family of scholars and musicians. While not encouraged to seek a career as a professional musician, he eventually studied piano in Boston and Berlin. He was trained as a performing artist, but he turned to composing and won early success with "Narcissus," a charming tune that was whistled and performed all over the world. His younger brother Arthur was also a gifted composer.

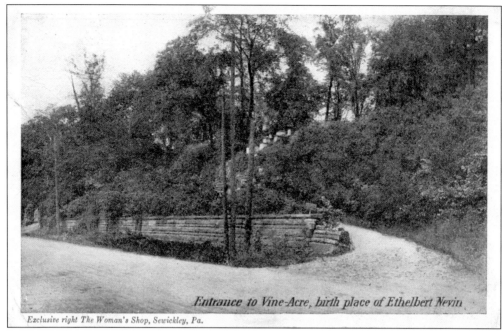

Entrance to Vine-Acre, birth place of Ethelbert Nevin

This card shows the entrance to Vineacre, the birthplace of composer Ethelbert Nevin. Although an internationally known artist who traveled widely, Nevin loved returning to his Edgeworth home and performing for the people who had known him all his life. Copyrighted by Sewickley photographer Aaron H. Diehl, the card was sold exclusively at a local shop.

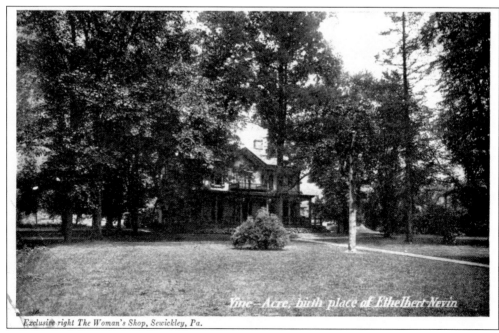

Vine-Acre, birth place of Ethelbert Nevin

Secluded on a ledge above Beaver Road in Edgeworth, Vineacre was built in 1861 by Robert Peebles Nevin, father of Ethelbert Nevin.

"The Rosary," a poem by Robert Cameron Rogers, had been brought to Ethelbert Nevin's attention by a family friend from Edgeworth. Nevin set the poem to music in 1900, and it became an instant success. A portion of the song is depicted on this card, which promotes a popular 1910 romance novel of the same name by English author Florence L. Barclay.

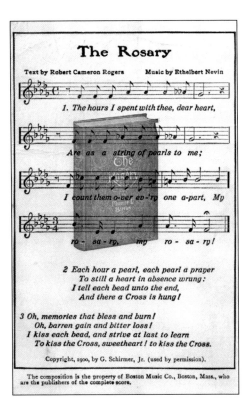

110 WINTER BEAUTY.

Postcards with a seasonal theme were a popular way to extend greetings or to add to a personal collection. This idealized version of a young lady is autographed by a member of the Edgeworth family of John C. Slack. The Slack home, Braeface, located on Beaver Road next to the home of Ethelbert Nevin, was a gathering place for musicians and for writers such as Willa Cather.

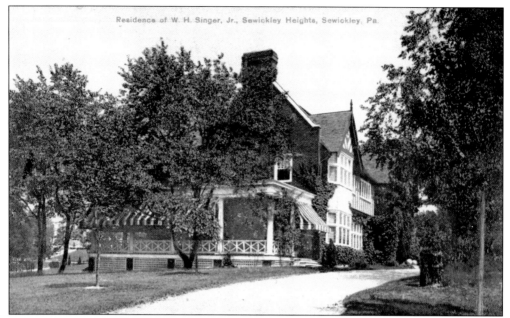

Harton Hall was the name chosen for this Tudor-style structure, one of the three dwellings on a large hillside estate owned by William Henry Singer, a Pittsburgh steel manufacturer. Harton was his wife's maiden name. The house was designed by Singer's son-in-law, William Ross Proctor, in 1902. It still stands on Chestnut Road in Edgeworth. It was actually the residence of George Harton Singer, not W. H. Singer Jr., as stated on the card.

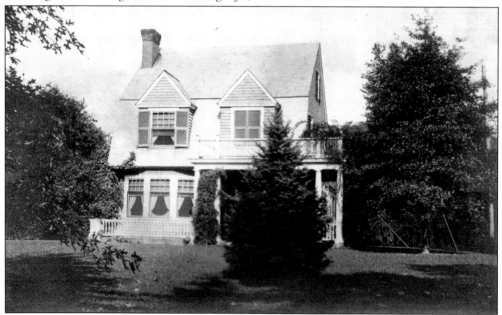

The charm of suburban living is exemplified by this stylish cottage built in 1898 by architect Frederick A. Russell for his bride. Russell's New England background is apparent in the design of the house, still extant on Newbury Lane in Edgeworth. Russell, who with his partner Frank E. Rutan designed many of the great houses of the Sewickley Valley, took an active role in civic affairs, serving as first burgess of Edgeworth Borough.

An ermine muff and scarf put the finishing touches on the winter outfit of Adelaide Mellier Russell, the daughter of Frederick Russell, seen in this postcard from about 1911. For many years, before marrying S. Douglas Ritchey, she was the owner of the Sewickley's Penguin Book Shop.

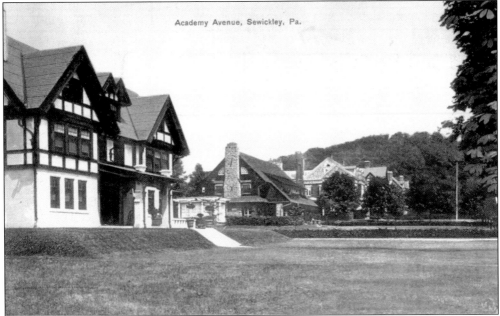

Academy Avenue, Sewickley, Pa.

Prime real estate in the eastern portion of Edgeworth remained undeveloped until the last decade of the 19th century, when the heirs of pioneer John Way began to sell off their vast holdings. Lots on the west side of Academy Avenue, the dividing line between Sewickley and Edgeworth, sold briskly. Fortunately, most properties remain intact today. At right in this card is the J. D. Culbertson house, aptly named Seven Gables.

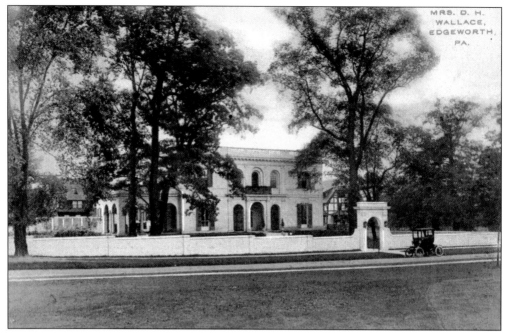

An Italian villa near the present Edgeworth Club seems incredible; however, it did exist. This white-walled mansion, built for Mrs. Daniel Henry Wallace (née Florence Walker), was a showplace during its short-lived existence. Vestiges of the wall are still visible, but the house is long gone. Soon after building her classical dream house, the owner settled in Italy.

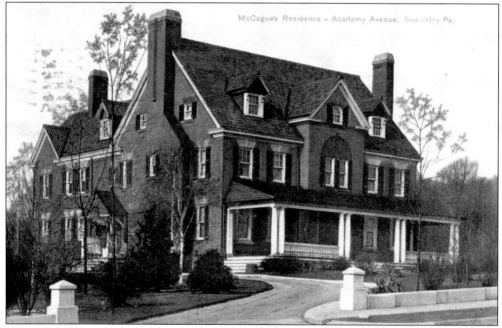

This Colonial Revival house, with its intricate tapestry brickwork, was published in the architectural press in 1902. Located at the corner of Academy Avenue and Woodland Road in Edgeworth, it was designed by Alden and Harlow for George E. McCague, a founder of the Sewickley Valley Hospital. The owners named their home Alanro Terrace. The house is no longer extant.

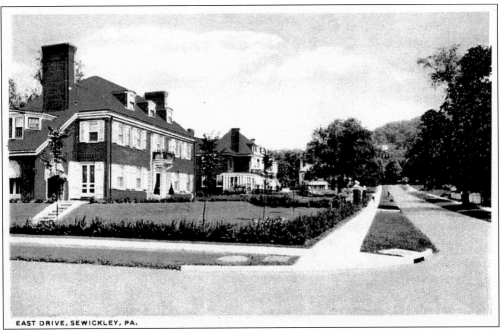

EAST DRIVE, SEWICKLEY, PA.

Although this card identifies East Drive as being in Sewickley, it is actually situated in the borough of Edgeworth. This entire row of houses, built in the first two decades of the 20th century, is intact today. With its close proximity to the Edgeworth Club, East Drive remains a prime residential address.

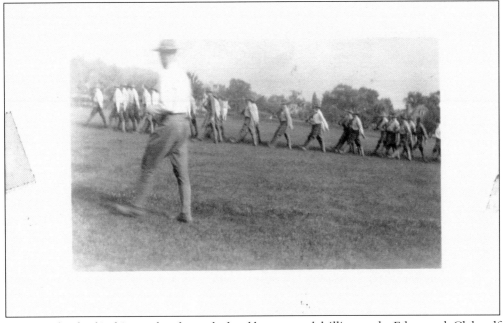

A rare card indeed is this one that shows the local home guard drilling on the Edgeworth Club golf course during World War I. Whether or not war would actually come to the United States was beside the point; these men probably yearned to be "over there." Those pictured here are believed to be Edgeworth men, but the corps drew members from surrounding boroughs as well.

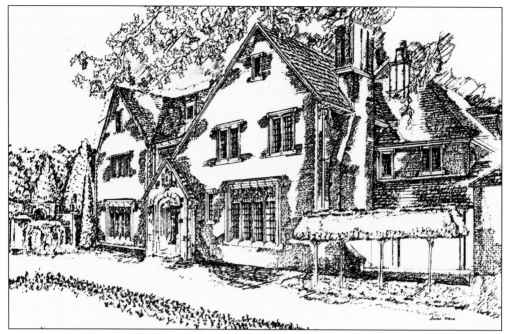

The handsome facade of this house, built for James C. Chaplin III in 1928, faces Creek Drive, Edgeworth. The Elizabethan Revival mansion was designed by Boston architect R. Clipston Sturgis, who was assisted by his nephew. Houses along East, West, Creek, and Irwin Drives were built between 1910 and the 1930s on what had once been the nine-hole golf course of the Edgeworth Club.

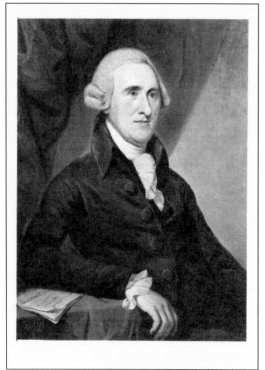

Thomas McKean, first governor of Pennsylvania, shown on a postcard from the Westmoreland Museum of American Art, was an early owner of land in the heights above Sewickley. His 1,600 acres were handed down to heirs living abroad, and the parcel called the Spanish Tract remained undeveloped. By the 1890s, however, that land, with its privacy, abundant clean air, and glorious views, attracted city residents who had the money to develop sprawling hilltop estates.

Looking very smug is Pa Pitt, who is escorting Miss Allegheny into the fold after a U.S. Supreme Court ruling made Allegheny City part of the city of Pittsburgh in 1906. What has this to do with Sewickley? Plenty, the Old Alleghenians would tell you. To them, this was a shotgun wedding. Many residents abandoned Allegheny, the third largest city in Pennsylvania, and moved to country homes in Sewickley Heights.

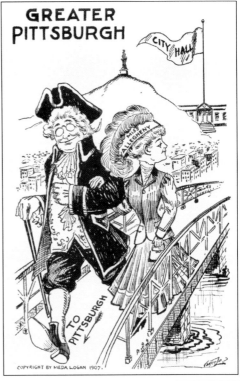

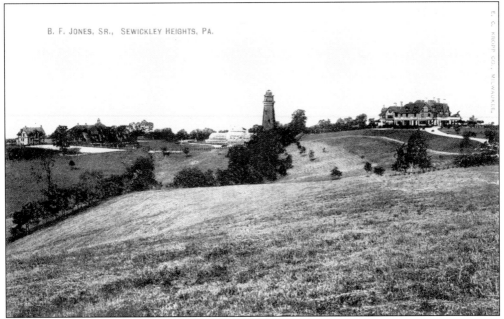

Mansions and water towers were the identifying marks of estates on Sewickley Heights after the migration of the iron and steel barons from Old Allegheny beginning in the late 1890s. Houses of 50 or more rooms on well-manicured grounds were not uncommon. Pictured here is Franklin Farm, home of Benjamin Franklin Jones Sr., partner in the great steel firm Jones and Laughlin.

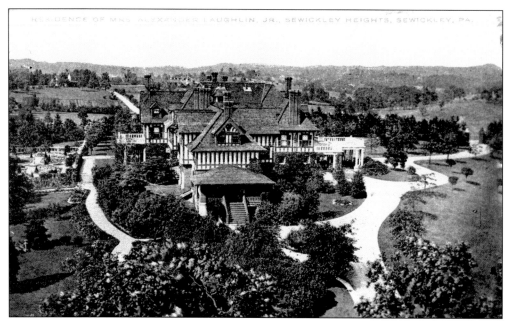

RESIDENCE OF MRS. ALEXANDER LAUGHLIN, JR., SEWICKLEY HEIGHTS, SEWICKLEY, PA.

This view of Franklin Farm, taken from the water tower on the estate, shows the elaborate gardens around the main house. In spite of the wealth of the owners, life on the grand estates was rural and self-sufficient, with lively competition to produce the finest specimens in the stables, barns, and greenhouses. The estate was inherited by daughter Mary Jones, who married Alexander Laughlin; thus the identification on the card.

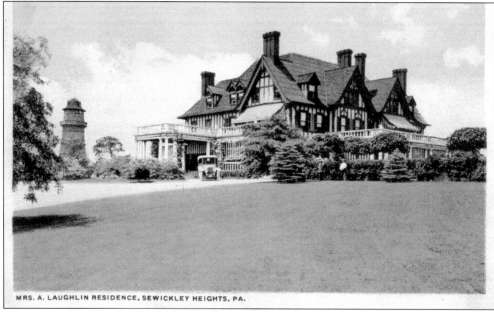

MRS. A. LAUGHLIN RESIDENCE, SEWICKLEY HEIGHTS, PA.

Franklin Farm was designed in 1899 by Rutan and Russell, with a later addition by Hiss and Weekes. It was razed in the 1960s. The water tower, which survives today after being damaged by lightning in 2002, was a necessity on the water-poor Sewickley Heights. Franklin Farm was famous for riding and driving parties, held every June in connection with the horse show at Allegheny Country Club.

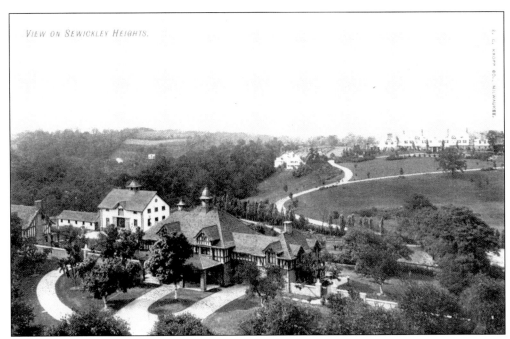

This view from the water tower looks over the barns and staff quarters at Franklin Farm, which still stand. Beyond are Hoey's Run valley and the Thaw property.

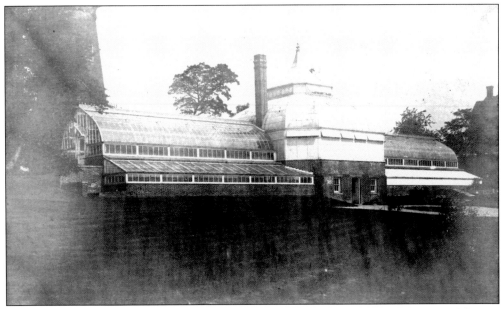

At Franklin Farm, the elegantly domed glass pavilion flanked by greenhouses produced flowers for arrangements in the many rooms of the mansion, and the keen competition at local shows encouraged the staff to take greenhouse gardening to new levels. Peter Demaso, under the supervision of Alfred Hunt, was the Franklin Farm greenhouse gardener for 50 years. Note the water tower looming at left.

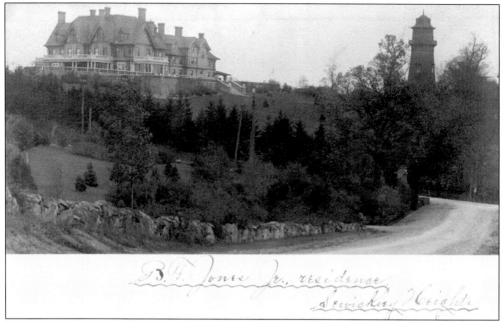

The writing on this dramatic view of Franklin Farm identifies it, incorrectly, as the B. F. Jones Jr. residence. B. F. Jones Jr. built his home, Fairacres, on the other side of Blackburn Road.

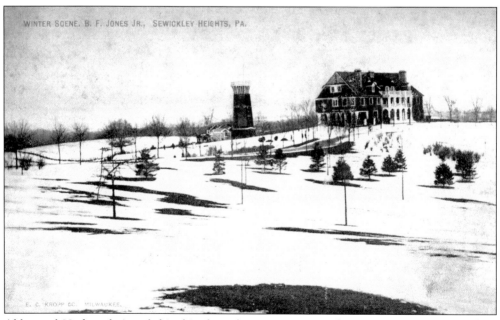

Alden and Harlow designed this shingle-style summer retreat for B. F. Jones Jr., scion of the Jones and Laughlin steel fortune, in 1899. It was the first of the mansions called Fairacres to be built on the 135-acre estate.

Here is another view of Fairacres I, the B. F. Jones Jr. estate on Sewickley Heights. The card is postmarked 1907. The stables here were among the finest in Western Pennsylvania, and Jones's daughter Adelaide Jones Burgwin was a leader in the equestrian world, founding the Sewickley Hunt with her husband in 1922. Her farm, called Barberry, was built nearby on a road of that name on Sewickley Heights.

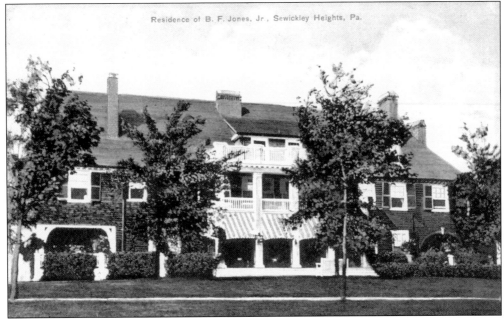

Residence of B. F. Jones, Jr., Sewickley Heights, Pa.

Airy, comfortable country living was what the iron and steel barons retreating from the smoky city were seeking when they built their summer "cottages" on Sewickley Heights. This is another view of B. F. Jones Jr.'s Fairacres I. In winter, the family lived in a town house on fashionable Ridge Avenue in Old Allegheny.

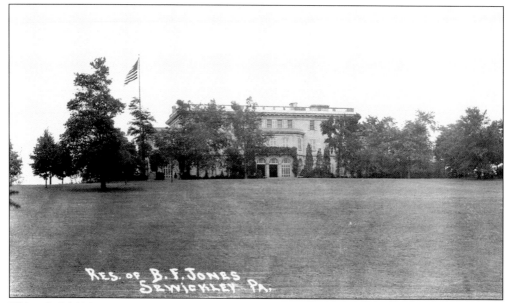

This palatial 100-room Beaux Arts mansion designed by Hiss and Weekes in 1917 for B. F. Jones Jr. replaced Fairacres I and allowed year-round living on Sewickley Heights. Fairacres II was also especially designed to accommodate the Jones' vast collection of English paintings. These were sold at auction in 1941 at the death of Mrs. Jones, and the house remained vacant until its demolition in 1964.

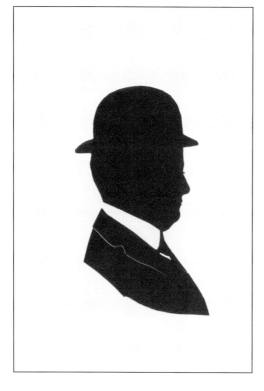

The charming idea of reproducing silhouettes on postcards preserves this image of B. F. Jones Jr. (1868–1928).

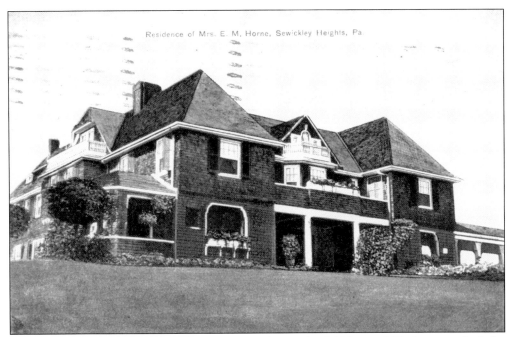

Ridgeview, which is unattributed but may be the work of Alden and Harlow, was built by B. F. Jones Sr. for one of his daughters, Elizabeth, and her husband Joseph O. Horne. The Jones' holdings on Sewickley Heights included four major houses, of which only this one survives. Mrs. Horne was the donor of the handsome B. F. Jones Memorial Library in Aliquippa, Pennsylvania, where a Jones and Laughlin steel mill was located.

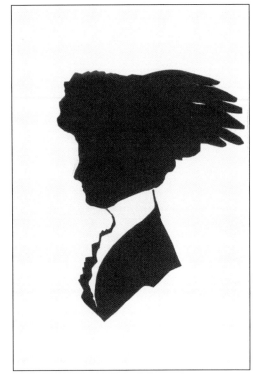

This is a silhouette of Mrs. B. F. Jones Jr. (née Sue Duff Dalzell [1866–1941]). In Pittsburgh, these were *the* Joneses to keep up with. Mrs. Jones's guest list determined the 400 of Pittsburgh society.

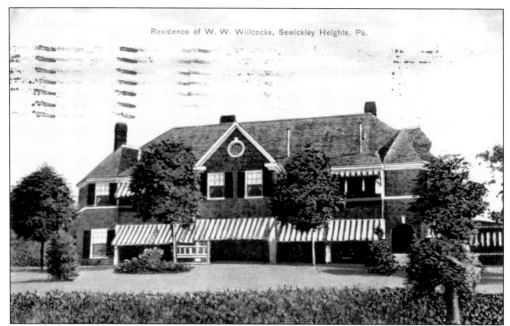

Residence of W. W. Willcocks, Sewickley Heights, Pa.

Gladmore Farm was the name bestowed upon this shingle-style summer home, unattributed but possibly by Alden and Harlow, built as a wedding present for Alice, another of the daughters of B. F. Jones Sr., and her husband, William Willard Willock. Notice the publisher's misspelling on the card. Willock was the general manager of the Monongahela Connecting Railroad and involved in Waverly and Willock oil companies.

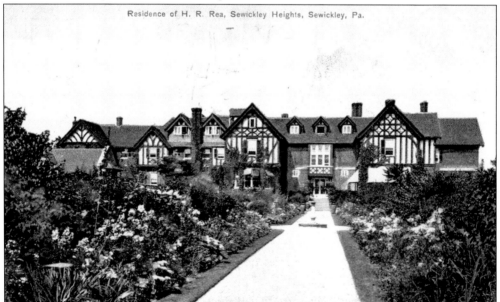

Residence of H. R. Rea, Sewickley Heights, Sewickley, Pa.

Social life on Sewickley Heights in the first half of the 20th century revolved around Farmhill, this Tudor Revival house, and its hostess, Mrs. Henry Robinson Rea. Designed in 1898 by William Ross Proctor, with additions by Hiss and Weekes and MacClure and Spahr, the showplace counted international celebrities and presidents among its guests. Mrs. Rea's father, industrialist Henry W. Oliver, had acquired the land in 1896. Farmhill was razed in 1952.

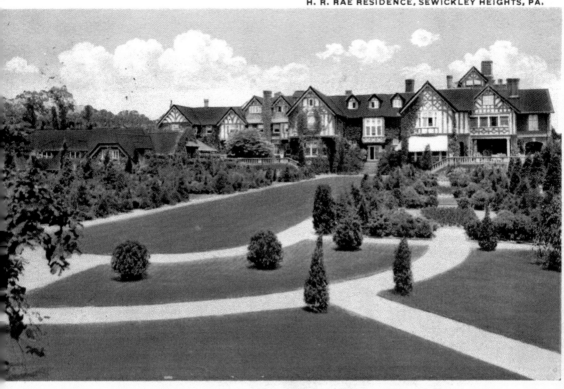

The 40 cultivated acres of Farmhill were lauded as one of the outstanding gardens of America in a 1928 issue of *Country Life*. The grounds included a 60-foot waterfall, a lily pond, a scented garden of heliotrope and lavender, and a dairy barn inspired by "Le Petit Trianon." The publisher of this postcard spelled the owner's name "H. R. Rae" rather than "H. R. Rea."

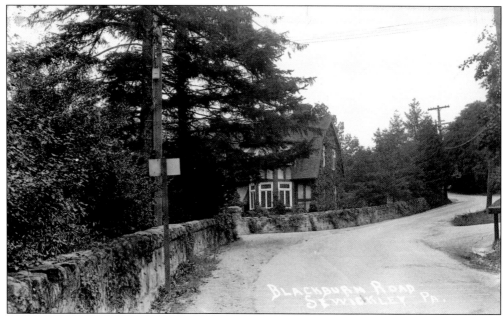

This postcard shows Blackburn Road, named for the minister of an early Sewickley Heights Methodist congregation. The stone wall on the left surrounding the Farmhill estate was commissioned by Edith Oliver Rea in the early 1920s. Supervising the wall-building project for Mrs. Rea was her faithful head gardener, Alexander Davidson, who already managed 18 gardeners and nine greenhouses on the estate. Davidson, a Scot, lived in this Tudor gatehouse, which remains today.

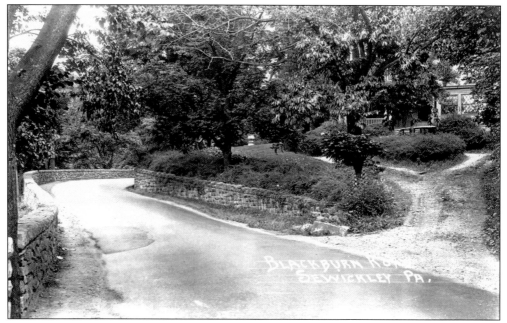

Italian stonemasons came on the train every day for several years to complete the more than mile-long stone wall that entirely surrounds the Rea property. At the right is a house built by contractor Daniel Challis, owner of a quarry on the hill above.

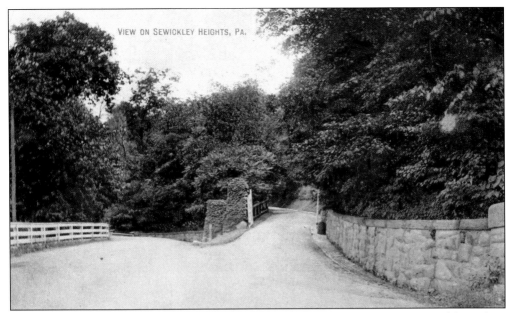

Shown here is the entrance, just below the hairpin turn on Blackburn Road, to one of the earliest Sewickley Heights estates. As You Like It, the summer home of Elizabeth Dohrman Thaw, was completed in 1902, with landscaping by the Olmsted Brothers of Boston. The grounds included a lagoon, a pergola dripping with wisteria, a vegetable garden, and 83 varieties of plants. Note the three-plank fence on the left that was replaced by Mrs. Rea's stone wall.

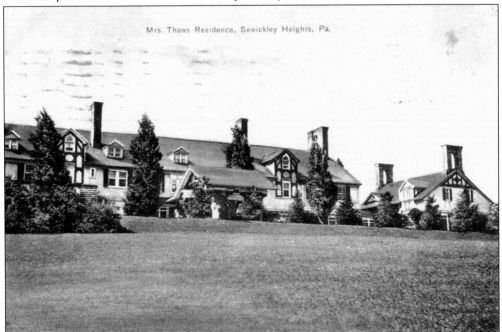

Mrs. Thaws Residence, Sewickley Heights, Pa.

As You Like It, a Tudor Revival house, was designed by George S. Orth for the widow of William Thaw Jr., a Pittsburgh coal merchant who was stepbrother of Harry Thaw, notorious for his 1906 shooting of architect Stanford White on the roof of the old Madison Square Garden. The 44-room mansion was truly a summerhouse; it had no central heating.

105

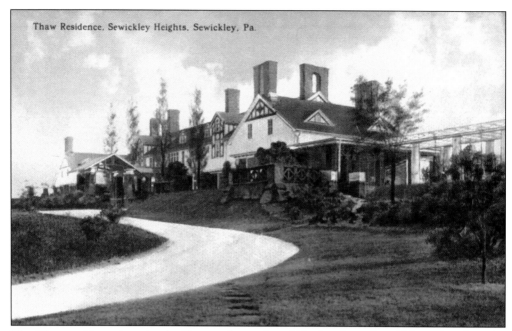

Thaw Residence, Sewickley Heights, Sewickley, Pa.

The Thaw residence lasted only 35 years. It was demolished at the order of Mrs. Thaw in 1937, and the site became a subdivision, Thawmont.

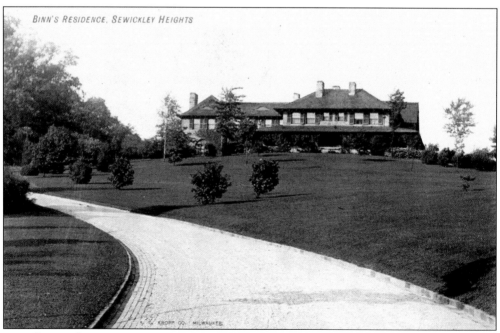

BINN'S RESIDENCE, SEWICKLEY HEIGHTS

A small stone along Country Club Road on Sewickley Heights inscribed with the word "Skipton" is a modest reminder of this great country house built by Mr. and Mrs. Ralph Holden Binns. It was designed by Rutan and Russell and erected about 1900 across from the estate of B. F. Jones Sr. In 1919, it was sold to Mr. and Mrs. Harry Darlington and renamed Highlawn. Harry Darlington was first president of Allegheny Country Club.

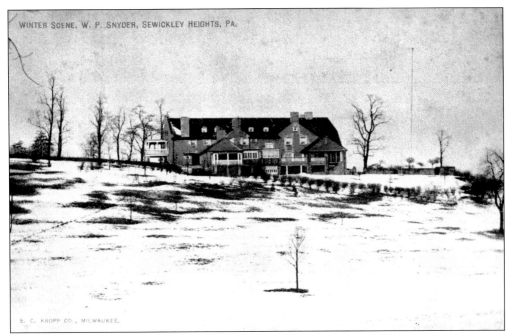

Wilpen Hall on Blackburn Road was designed in 1898 by George Orth and Brothers as a summer home for Mr. and Mrs. William Penn Snyder, whose primary residence was in Allegheny City. Wilpen Hall later became the permanent home of the Snyder family, who still reside there today.

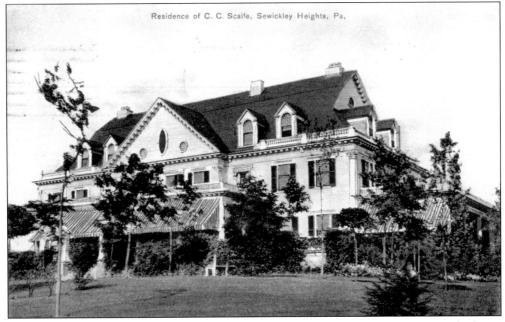

Woodmont was designed by architects Vrydaugh and Wolfe in 1902 for Mr. and Mrs. Charles C. Scaife. Although altered, this Colonial Revival mansion survives on Scaife Road in Sewickley Heights. A grand staircase is an outstanding feature of its interior.

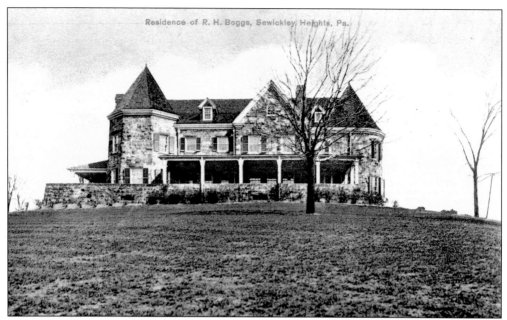

This twin-turreted castle named Hohenberg was situated on Backbone Road, Sewickley Heights. It was designed by Alden and Harlow in 1900 as a summer home for Russell H. Boggs who, with Henry Buhl, was a partner in the Boggs and Buhl Department Store in Old Allegheny. Buhl, who endowed Pittsburgh's Buhl Planetarium, also built a summer home in Leet Township named Cloverton Hills. Neither house survives.

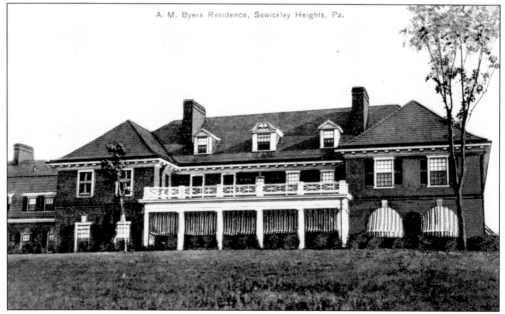

Poplar Hill, built for Mrs. A. M. Byers, overlooked the Allegheny Country Club golf course. Designed by Hiss and Weekes, this comfortable house was erected in 1904. In 1910, Goodwood, a Tudor Revival house by MacClure and Spahr, was built close-by for son John Frederick Byers. Neither house has survived, but the Byers' townhouse in Allegheny City lives on as headquarters of the Community College of Allegheny County.

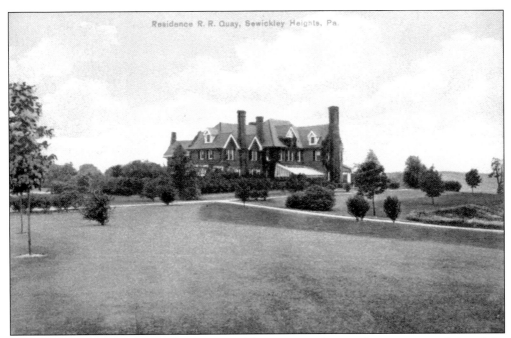

Residence R. R. Quay, Sewickley Heights, Pa.

Bellamona on Backbone Road was designed by Rutan and Russell. It was commissioned for Sen. Matthew S. Quay, who died before if was finished in 1904. His widow and son Richard Roberts Quay lived in the house. There was a 1914 addition designed by Brandon Smith.

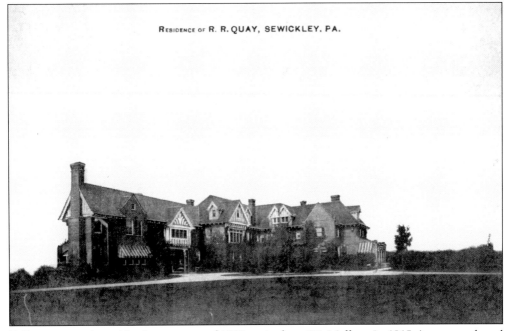

RESIDENCE OF R. R. QUAY, SEWICKLEY. PA.

Bellamona was leased in the summer of 1913 to Andrew W. Mellon. In 1915, it was purchased by Col. J. M. Schoonmaker, president of the Pittsburgh and Lake Erie Railroad. The house survived until 1959.

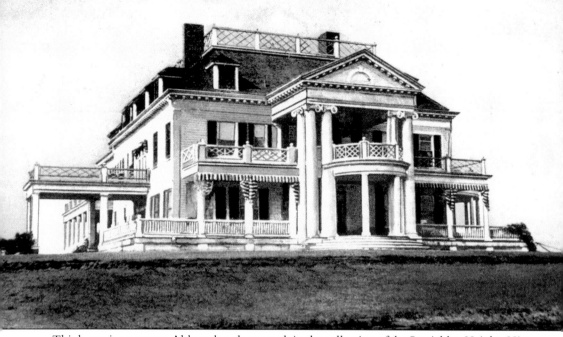

This house is a mystery. Although a photograph in the collection of the Sewickley Heights History Center seems to show the house in the vicinity of the Jones estates on Blackburn Road, no one knows whose it was, when it was constructed, or by whom it was designed. This reminds us that a house such as this, which would be remarkable in most other communities, can be lost to history here because of the large number of such properties that graced the Sewickley Valley.

Four

SOCIAL LIFE AND LEISURE

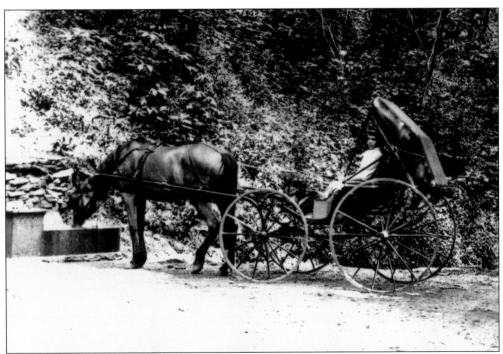

Social life and leisure in the Sewickley Valley centers around numerous public parks and green spaces, where beautiful scenery abounds, as well as private clubs and an active YMCA. This photograph shows Myra McCleery Wrenshall watering her horse at the spring on Little Sewickley Creek Road.

The celebrated Little Sewickley Spring mentioned on this card is the horse trough and fountain shown in the previous photograph. Little Sewickley Creek Road was a favorite place for the local gentry to ride in the horse-and-buggy days. The trough, designed by architect Frank E. Rutan, was a gift of Thomas Leet Shields. It is missing today.

For years, automobiles, by gentleman's agreement, refrained from trespassing on Little Sewickley Creek Road, leaving it to horse riders and carriages.

Here is the reverse of the previous card, postmarked 1907, with a green 1¢ Franklin stamp, mailed at Sewickley and received at Shields. Addressed to Elizabeth Walker at "Muottas," it reads, "I'm supposed to be studying my Algebra and I am after a fashion, but my heart is not here, it's out on the Little Sw'k'y. road riding horseback with you and Tweed. from – Guess who!"

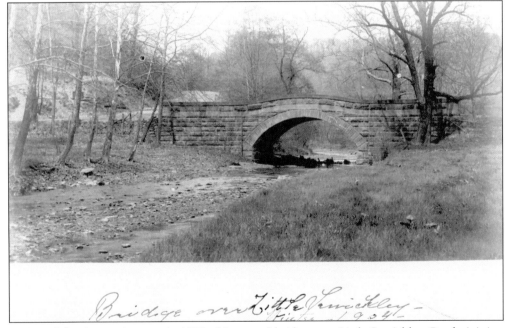

Designed for the carriage era in 1889, this second bridge over Little Sewickley Creek, joining what is now Woodland Road with Little Sewickley Creek Road, was built by stonemason William Dickson. Dickson also supplied the stonework for Sewickley's yellow brick public school. The bridge carries automobile traffic today.

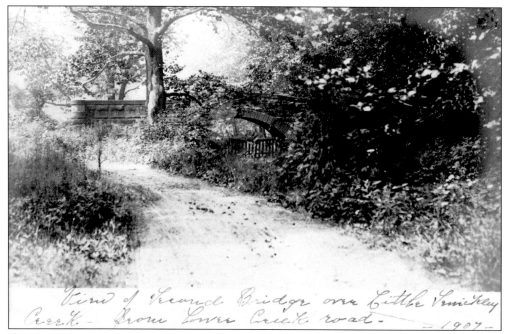

View of Second Bridge over Little Sewickley Creek - from Lower Creek road. - 1907 -

Here is another view of the picturesque stone arch bridge over Little Sewickley Creek. It spans the "old swimming hole" and was once a famous parking place for bicyclists.

This more modern view of the second bridge over Little Sewickley Creek, showing a boy fishing, was produced by the Little Garden Club of Sewickley, one of the many garden clubs in the Sewickley Valley. The photograph is by Michael J. Merante.

LOWER ENTRANCE
Mt SEWICKLEY GROVE

Mt. Sewickley

is a delightful place to spend a day or your entire vacation. Just fourteen miles west of Pittsburgh on the Ft. Wayne Railroad. One mile from Leetsdale Station. ∴ ∴

In 1868, the Mount Sewickley Camp Meeting Grounds were built in a grove of oaks on a hill above Leetsdale. Founded by the Methodists at the same time as Chautauqua, Mount Sewickley was dedicated to promoting friendship and the work of God. Besides picnic groves and cottages, there were at one time three hotels, recreational facilities, and a tabernacle for non-denominational religious services. Today the area is a residential subdivision.

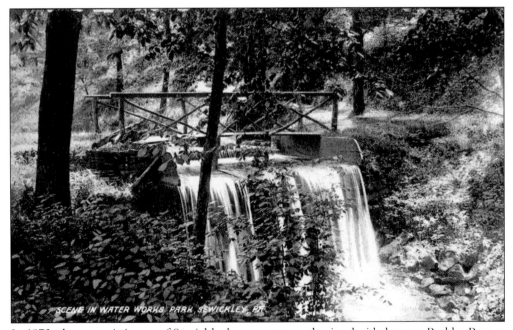

SCENE IN WATER WORKS PARK, SEWICKLEY, PA.

In 1873, the commissioners of Sewickley's new water authority decided to use Peebles Run as its water source. The run, which comes from the hills near what is now Dickson Road, could be tapped high enough that the water flowed by gravity. By 1874, the work was completed, resulting in both a dependable water supply and a beautiful park. Water Works Park preceded Schenley Park, Pittsburgh's first, by 15 years.

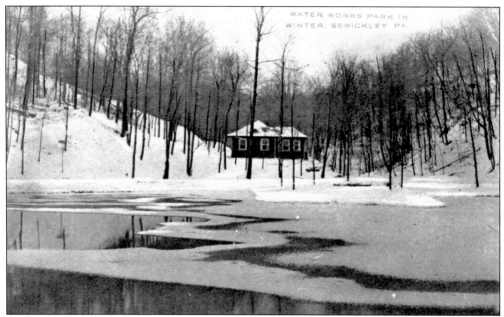

A 19th-century pamphlet notes that "the only public park of Sewickley is the improved ground above the water reservoir . . . a delightful place, with its rustic seats in odd corners, its many walks along creek banks, up the hillside among trees, over rustic bridges, past full flowing springs in unexpected places, and over the water dams. For quiet places to meditate [or] for a little family picnic, it is all that could be desired."

Water Works Park was the scene of picnics held every summer by the Cochran Hose Company, as well as the meeting place for the early-morning bird-watching walks of Sewickley's Audubon Society. The landscape of the park was at one time kept manicured by a staff of 26 men. The reservoirs are now covered, and the park is closed to the public.

116

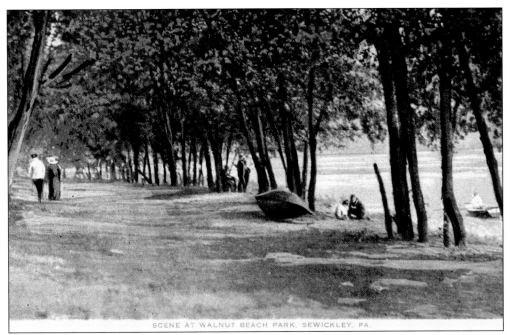

SCENE AT WALNUT BEACH PARK, SEWICKLEY, PA.

Walnut Beach, Sewickley's summer resort at the foot of Ferry Street, was the brainchild of James S. Gray, a civic-minded tailor with a shop on Beaver Street. Opened in 1915, it had abundant shade, playgrounds, amusements, a pavilion for roller skating and dancing, refreshment stalls, and bathhouses. The "beach" was a place where the river was shallow and had a gravel bottom.

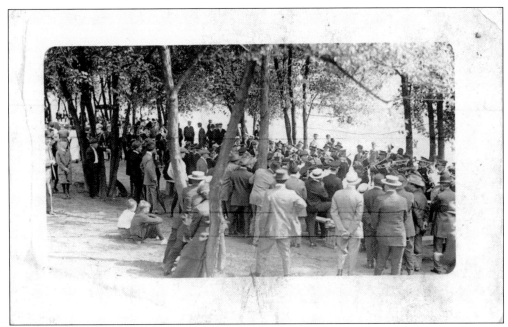

By 1920, there were 80 camps on the grounds of Walnut Beach, with a waiting list for 50 more. Families stayed for the summer, with the men commuting from Pittsburgh on weekends. The *Sewickley Herald* called Walnut Beach "a miniature Atlantic City." On holidays, visitors to the beach nearly doubled the population of the borough.

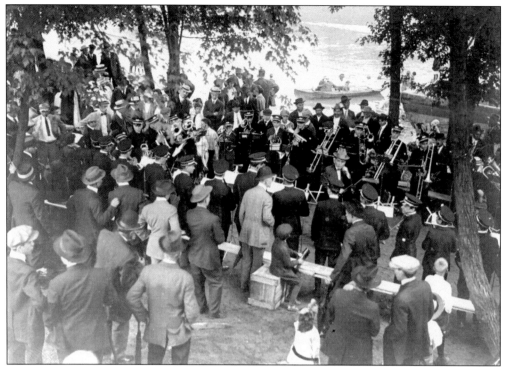

Excursion boats docked at Sewickley's Chestnut Street landing, and the trolley came across the Sewickley Bridge, bringing Pittsburghers to Walnut Beach. Here is a band concert under the trees, with boaters on the river. The beach was finally closed in 1927, buried under tons of slag fill by the Pennsylvania Railroad in preparation for moving the tracks closer to the river.

This is a view of Peters' Cabin, moved in the 1970s to a site in Sewickley Heights, which stood in what is now Walker Park. More than 80 acres along Little Sewickley Creek in Edgeworth and Leet Township were donated for public use in 1934 by Mr. and Mrs. William Walker. Mr. Walker was active in preservation and organized the River Front Protective Organization, whose members sought to preserve the Sewickley Valley landscape from development.

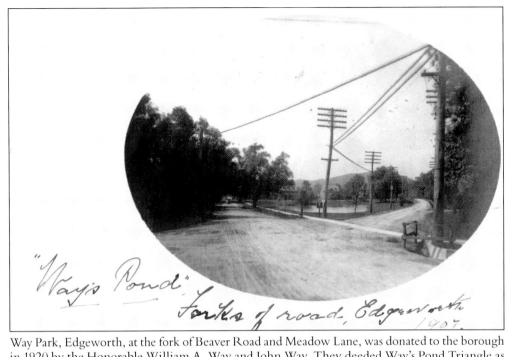

"Way's Pond" Forks of road, Edgeworth 1907.

Way Park, Edgeworth, at the fork of Beaver Road and Meadow Lane, was donated to the borough in 1920 by the Honorable William A. Way and John Way. They deeded Way's Pond Triangle as a memorial to their father, John Way Jr., who had lived in the Abishai Way house overlooking the park. The pond was drained after World War I because of complaints about mosquitoes.

Way Park, with its beautiful arched stone bridge and specimen trees, is a popular background for wedding photographs. This was the scene of the Sewickley Valley Bicentennial Band Concert in 1976 and the Edgeworth Borough's centennial celebration in 2004. In the park is a monument to Edgeworth's World War II veterans.

Jean Pontefract
age 11, 1905

Jean Pontefract, pictured here, was a daughter of James G. and Elizabeth Walker Pontefract of Bagatelle. Morrow-Pontefract Park, on Beaver Road in Edgeworth, beside Little Sewickley Creek, was established in 1956 on land donated by Mr. and Mrs. John D. A. Morrow in memory of their son and by the heirs of Elizabeth Pontefract and William Walker. It is dedicated in perpetuity to the preservation of wildlife and the enjoyment of the borough's citizens.

Sewickley Arts Festival
...for the playground

Saturday, September 11, 2004 • 1:00 – 7:00 pm
War Memorial Park, Sewickley

War Memorial Park, formerly administered by the Sewickley Valley War Memorial Association, opened in 1951 on land that was originally a private golf course on the Rea estate. Expanded to about 27 acres in 1959 with the donation of adjacent land by local residents, it is dedicated as a living memorial to veterans of all of our nation's wars. This card advertises a festival held to raise funds for a new playground in the park, which was installed in 2006.

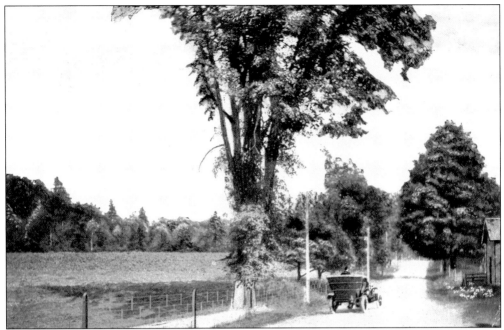

With no traffic, no hurry, and a million places to go, driving in the old days was very popular. Joseph Warren is credited with owning Sewickley's first gasoline-driven automobile, a Locomobile runabout. By 1905, Sewickley residents owned five Franklins, seven Oldsmobiles, three Packards, and a Winton. There were 13 Pope-Waverlys, an electric car, and some Stanley Steamers. There was also one DeDion and Bewton motorette propelled by benzene.

"BEAUTY SPOTS" HIGHWAYS - SEWICKLEY, PA.

This card, printed in brilliant color, invites the motorist to hit the road on Sewickley's byways.

"BEAUTY SPOTS" NEAR SEWICKLEY, PA.

This is another card from the "Beauty Spots" series.

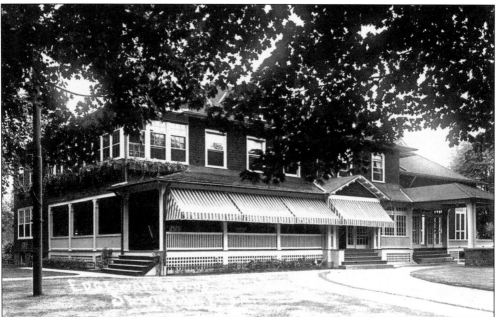

The Edgeworth Club was founded in 1893 in what is now a private residence on Meadow Lane. In 1897–1898, it moved to the frame building shown here, designed by architects Rutan and Russell, located on the Sewickley side of Academy and Centennial Avenues. This view of the Academy Avenue entrance is from around 1925 and shows a later extension to the rear of the side veranda.

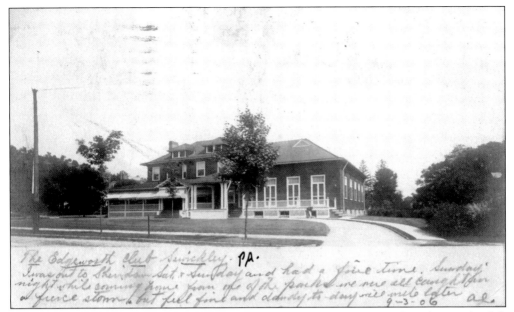

The Edgeworth Club Swickley PA. I was out to Sheridan Sat. & Sunday and had a fine time. Sunday night while coming home from one of the parks we were all caught in a fierce storm but feel fine and dandy to-day will write later. 9-3-06 a.e.

In keeping with its purpose of providing "facilities for innocent sports," the Edgeworth Club opened a nine-hole golf course in 1900. This was the second course in Sewickley; another nine-hole course at the end of Woodland Road, Shields Golf Club, had been founded in 1898. The Edgeworth Club links outlived the Shields course and survived until 1912. This second clubhouse building burned to the ground on December 28, 1928.

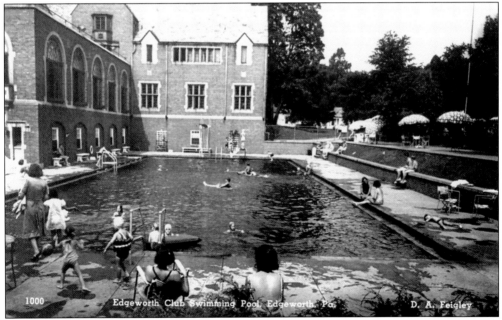

1000 Edgeworth Club Swimming Pool, Edgeworth, Pa. D. A. Feigley

Shown here is a 1938 photograph of the swimming pool at the present home of the Edgeworth Club, a Tudor Revival building designed by architect Brandon Smith and completed in 1931. The clubhouse is located on Beaver Road and Academy Avenue, with its entrance on East Drive. Its architectural style and size are compatible with the residential neighborhood, and the club continues today as a center of social life in the Sewickley Valley.

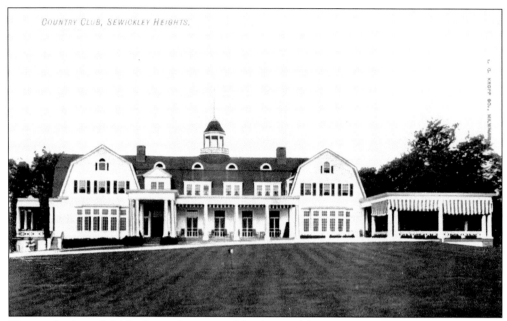

The gambrel-roofed Allegheny Country Club, designed by William Ross Proctor, opened on Sewickley Heights in 1902. The club was founded in 1895 and first located in a Victorian frame house on Pittsburgh's North Side. The move to Sewickley Heights paralleled the building of summer homes here by the wealthy businessmen of Pittsburgh.

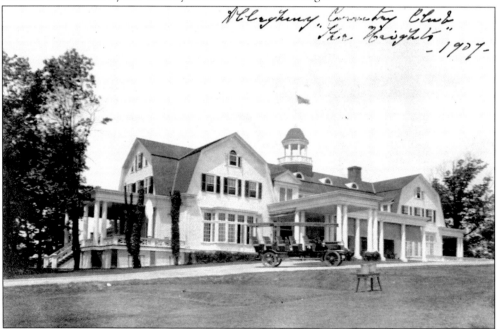

The entire setting for Allegheny Country Club—clubhouse, golf course, and land—was financed by only 100 members. The acreage was part of what had been the McKean holdings. According to the *Pittsburgh Bulletin* of May 17, 1902, "On a suitable point of land is placed the . . . club house, making a striking feature of the landscape It is an edifice of splendid proportions and artistic design."

Besides golf, the club offered tennis, an ice-skating pond, and riding. By 1910, Allegheny sported stables for 70 horses, a show ring, and riding and driving trails. The Allegheny Country Club Horse Show was one of the outstanding shows of its kind in the United States for many years. International Davis Cup matches were held on Allegheny's grass tennis courts in 1914 and 1921. The country club is still the focus of social life on Sewickley Heights.

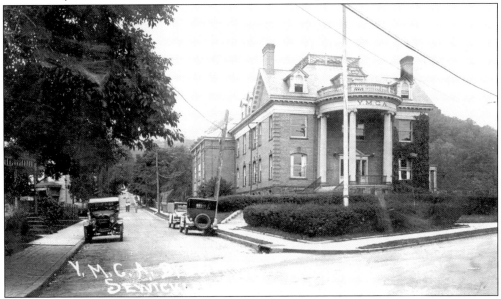

A grand building indeed is this imposing Georgian headquarters of the Sewickley YMCA, which opened its doors at the intersection of Division Street and Blackburn Road on May 16, 1904. The property on which it is located was a gift of industrialist Henry W. Oliver. Prior to 1904, the YMCA met on the third floor of the First National Bank Building at the corner of Broad and Beaver Streets.

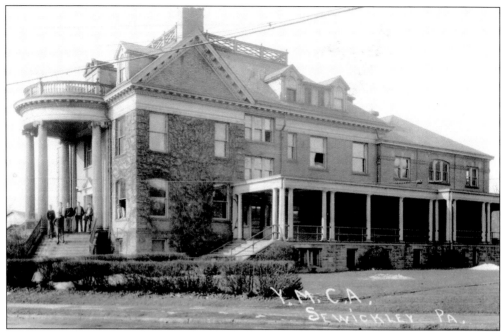

Here is another view of the YMCA, showing the sun porch on the right that was removed for the 1968 expansion of the facilities.

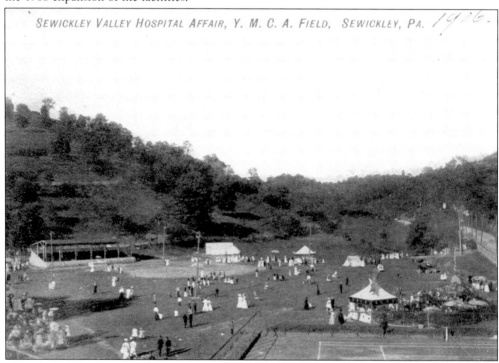

The grounds of the YMCA replaced the old Sewickley Athletic Field on Nevin Avenue as the popular gathering place for field sports and tennis and, later, golf. Athletic contests of all sorts took place there, plus events such as circuses. This gathering in 1906 was probably a country fair organized to benefit the Sewickley Valley Hospital, then under construction.

This handsome Colonial revival house on Broad Street was built in 1866 for David Nye White, editor of the *Pittsburgh Daily Gazette* and a founder of the national Republican Party. It continued as a private residence until 1923, when it was purchased by the Masons of the Sewickley Valley for the Dorian Club. Meetings of all sorts were held here until the 1960s, when the building was razed for a church parking lot.

Caves with such fascinating names as Bell Rock and the Post Office yawned on the Sewickley hillsides below weather-worn sandstone outcroppings and were familiar to every local lad who had the gumption to probe subterranean mysteries. Most have been filled in today. Despite stories that the caves went under the river and came out on the Coraopolis side and were used as an Underground Railroad during the Civil War, geologists say it just is not so.

WHERE WE HUNT LOB-
STERS AND EAT THEM

The visiting traveler could find the usual tourist fare in Sewickley, as in any other place. In closing, two examples are offered. The reference on the 1913 card on the left to lobsters in Western Pennsylvania is enigmatic!

"WHEN SHALL WE THREE MEET AGAIN IN SEWICKLEY?"